THE
PHOTOGRAPHY
IDEAS
BOOK

Inspiration
and tips taken
from over
80 photos

Lorna Yabsley

ilex

Contents

THE
PHOTOGRAPHY
IDEAS
BOOK

An Hachette UK Company
www.hachette.co.uk

First published in the United Kingdom in 2019 by
ILEX, an imprint of Octopus Publishing Group Ltd
Octopus Publishing Group
Carmelite House
50 Victoria Embankment
London, EC4Y 0DZ
www.octopusbooks.co.uk
www.octopusbooksusa.com

Front cover image © Adrian Wojtas
Back cover image © Sarah Le Brocq

Distributed in the US by Hachette Book Group
1290 Avenue of the Americas, 4th and 5th Floors
New York, NY 10104

Distributed in Canada by Canadian Manda Group
664 Annette St., Toronto, Ontario
Canada M6S 2C8

Publisher: Alison Starling
Commissioner: Frank Gallaugher
Managing Editor: Rachel Silverlight
Art Director: Ben Gardiner
Designer: e-Digital Design
Picture Research: Giulia Hetherington
Senior Production Manager: Peter Hunt

Ilex is proud to partner with Tate in our publishing programme; supporting the gallery
in its mission to promote public understanding and enjoyment of British, modern and
contemporary art.

ISBN 978-1-78157-666-3

A CIP catalog record for this book is available
from the British Library

Printed and bound in China

10 9 8 7 6 5 4

MIX
Paper | Supporting
responsible forestry
FSC® C008047
FSC
www.fsc.org

Introduction

Photography is different from any other form of art. It may have been weeks, months or even years since the last time you visited a gallery and looked closely at a painting or sculpture, while odds are that you'll have seen several hundred photographs before the end of today. The ease with which modern devices allow us to create beautiful images is incredibly liberating, but also inherently exhausting – if everyone is taking photos of everything, what's left for you to make your mark with?

Fortunately, this is a false premise; there is no more a limit to the number of original photographs you can take than there is a limit to the number of great novels left to be written. Peppers weren't exactly a hot commodity when Edward Weston created *Pepper No. 30*; nobody saw the beauty in industrial water towers until Hilla and Bernd Becher photographed hundreds of them; and grocery stores weren't considered a particularly dazzling subject when Andreas Gursky created *99 Cent*, but that didn't prevent it from drawing a record-breaking £1.7 ($3.3) million when it was sold at auction in 2007.

And it's not just the giants of photography that you should look towards to find your inspiration. You're part of a modern movement in photography, whether you're aware of it or not, and photographers around the world are constantly experimenting, bringing old techniques to new subjects and connecting their photographs to current events.

This book is for everyone who takes photos, whether that be with a state-of-the-art DSLR, an iPhone or an antique large-format, wet-plate camera. If you're stuck in a rut or just want to try something new, you'll find a wealth of inspiration in these pages. While you're dabbling in some classic techniques, trying out some novel approaches and learning from the masters, you'll break out of your rut and dive into a new phase of your photography with a rejuvenated sense of creativity and wonder. Let's get started.

Obscure

For this series of images, photographer Rosanna Jones emptied several containers of milk powder into a bathtub and had her model lie back, revealing only a few exposed body parts disappearing into white. The conversion of the image into grainy, high-key black and white intensifies the ghostly effect.

There's a place for elaborate sets and photo manipulation, but great images often come from committing yourself to an off-the-wall idea and following it through. In this case, a beautifully simple idea (assuming you have an open-minded model) that immediately captures your attention and makes you wonder how the image was created.

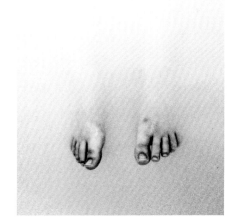

ABOVE & OPPOSITE:
From the series *Body*

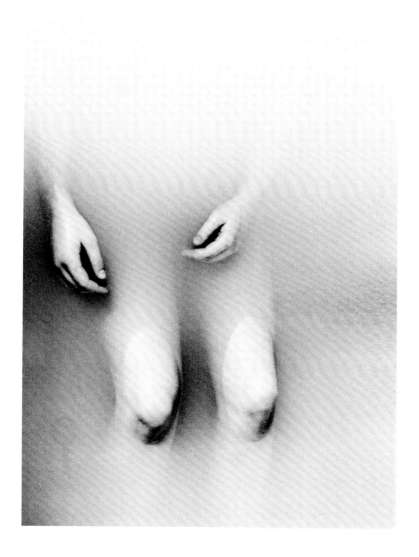

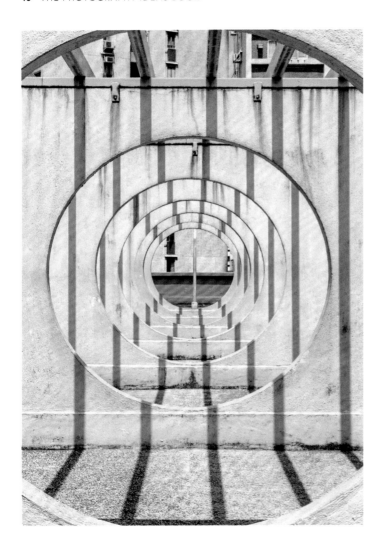

Perspective

Nature may not work in straight lines, but urban environments are full of them and often are built to pull attention in a particular direction or towards a viewpoint. The trick to capitalizing on this in a photograph is to frame your shot as perfectly as possible – level with the horizon, parallel to any flat surfaces so there's no keystoning, and so on. This is the time to utilize the tools at your disposal, so bring a tripod and use gridlines to help you line everything up.

Here, Joel Fulgencio also used the shadows created by direct midday sun to add the strong repeating vertical elements; such high contrast is unflattering for portraits, but fantastic for generating graphic images like this.

OPPOSITE:
Hong Kong

Colour Match

A simple way to connect a portrait subject with their environment is to match the colour of the sitter's clothing with something in the background. This portrait by Prince Akachi benefits from a rich, textured background and the design of the blazer that work together to draw the viewer in and pull attention to the elements that stand out – the model's face and hand gesture.

This naturally requires some planning ahead, both in terms of scouting a location or creating a set and selecting an appropriate costume. Simply bringing several outfits to a shoot and challenging yourself to find a matching background can be a fun way of performing a fashion shoot on the fly.

OPPOSITE:
From Mars with Hope

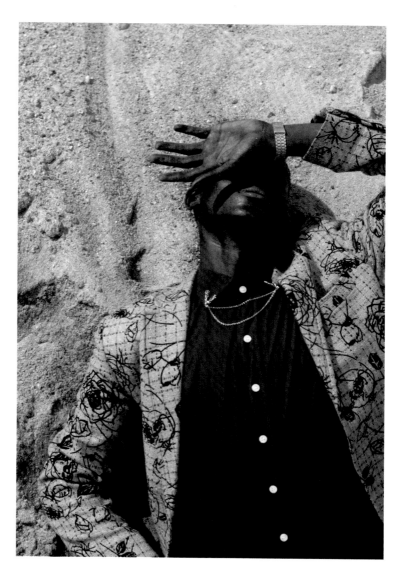

Found Photographs

Does it count as photography if you didn't take the photo? To most, the intuitive answer would probably be 'no'. But taking the shot is just one part of a much larger process: later, you develop the film or import the file, you spend a little or a lot of time making post-production edits, and you choose how and where to present the results.

Here, Millie Elliott mixes analogue and digital processes to transform the shots. By placing them in new orders and contexts, she removes them from their original meanings, inviting the viewer to form their own narrative.

The next time you're feeling stuck for a subject, why not simply leave the camera at home and put all your creativity into the other end of the process? It's a good way to learn or remind yourself just how many choices you have beyond when to push the button. Search flea markets or public domain archives, or make it a social project and ask a friend if you can swap a number of photographs, and then see how much you can transform them.

BELOW:
From the series
Work in Progress
OPPOSITE:
From the series
Order From Chaos is Common

Backdrop

Ibrahim Azab's *Out Of Touch* project questions concepts of photographic authenticity and authority, and the viewer's willingness to believe – and even feel – what they see.

In each of the images in this series, what appears at first to be a straightforward composition is made uncanny by the insertion of an interacting body part into the scene. Closer inspection reveals the images to be even stranger, as the viewer realizes that the scene is in fact a photographic backdrop. Discovering the illusion emphasizes the tangible sense of connection experienced by the viewer at the point of the fake interaction.

Photographing a photograph is an interesting way of creating an analogue composite image. Some things to consider if you want to try this technique include: How big does the base photograph need to be, and on what surface should it be printed or screened to be re-photographed? Do you want to try to make it look realistic, or accentuate the falsity? Will your image be only one shot removed from reality, or several?

OPPOSITE:
Two Plus Years from the series *Out Of Touch*

Freelensing

If you have an interchangeable-lens camera, you can try this technique to create extraordinary images that utilize an unnatural, extreme depth of field. Freelensing involves detaching your lens and holding it in front of the camera. You won't be able to use the focus ring or change the aperture, but your camera will still be able to record an image.

By employing this technique, you can mimic the effects of a tilt-shift lens, placing the focus over a specific part of the frame while the rest is allowed to fall out of focus. This effect often works best in close-up shots, such as this intimate portrait taken by Florian Pérennès.

OPPOSITE:
Sweet Dream

Tilt

When you're framing a shot, you have a tremendous
amount of power over a viewer's perception of an image.
Here, Léonard Cotte simply rotated his camera to line
up horizontally with the slope of a hill rather than the
apartment building behind it – a very small act that turns a
normal sunny day into a surreal perspective.

OPPOSITE:
Swinging Perspective

Shadow Sketches

Cailean Couldridge's shadow sketches riff on the classic photogram technique, whereby objects are placed directly onto photographic paper and exposed to light. This results in a negative shadow image, which becomes visible only once the print has been developed, where solid objects between the light and the paper show as white shapes against the black of the exposed paper.

In this series, Couldridge used the light of a flame to 'paint' the objects on the paper. By controlling the light source, he was able to shape the shadows, making them a part of the image. The effect seems random, but it's the result of considered, conscious action.

Photograms are experimental by nature and easy to make if you have access to a darkroom or can create your own light-proof space. Look to artists such as Man Ray and László Maholy-Nagy for more inspiration for creative photograms.

..

OPPOSITE & ABOVE :
From the series
Sketches of Shadows

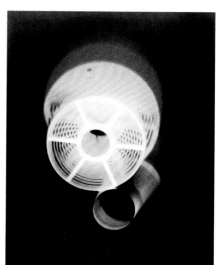

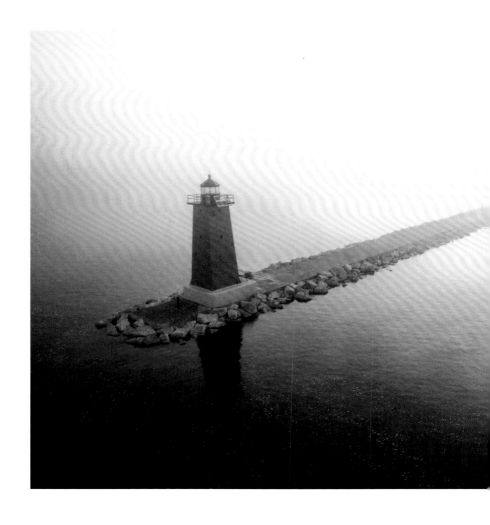

To the Sky

Drone photography is very new, with cheap hobby drones having opened up the world of aerial photography to consumers. It's easy, however, to fall into the trap of celebrating the novelty of drone images without giving due consideration to their composition. An open stretch of landscape without any clear subject might catch your eye due to the unusual viewpoint, but it probably isn't a very good photograph.

For this shot, Aaron Burden scouted his subject in advance, he waited for the sun to balance out the lighthouse in the frame, and finally created an image that is about more than just the novelty of its viewpoint. The photograph succeeds due to skill and preparation, rather than mere luck.

LEFT:
Alone on the Water

Collage

Pete Kirby's images are presented in the form of a digital collage. At first glance it might appear that a grid has been superimposed on top of a shot of a tree. In fact, closer inspection reveals that each of the frames that comprise this image is an individual photograph. It's a digital collage reminiscent of David Hockney's photographic 'joiners', in particular his collages of swimming pools, constructed out of dozens of white-bordered Polaroids.

Kirby's technique is intended to represent the way we perceive our surroundings: our eyes gather information from details that are collected into a coherent picture by our minds, in a combined effort between sensory perception and memory. Not one 'decisive moment', therefore, but a series of episodes as our eyes assemble the picture piece by piece.

This method suits any number of stationary subjects. Replicate Kirby's process by taking all your shots quickly during a single shoot so that the lighting conditions are the same throughout, or see what happens when you try this over a changing time period – a day, a week, a month or longer.

OPPOSITE:
L'arbre merveilleux.
Brittany

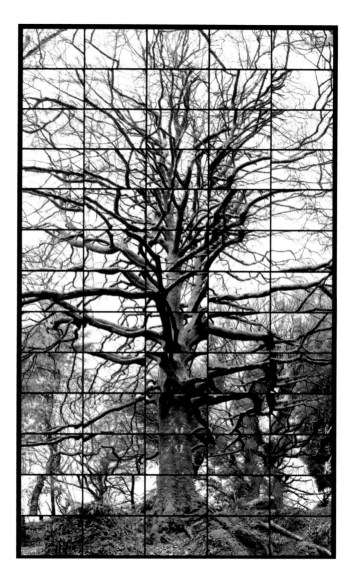

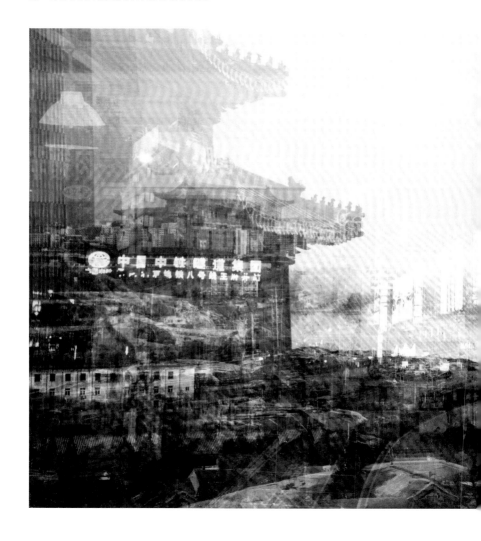

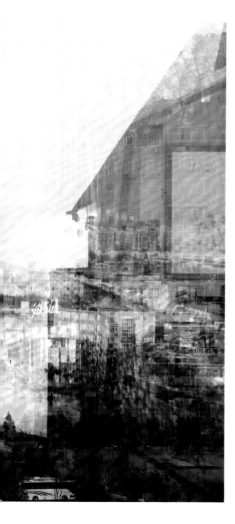

Multiple Exposure

Multiple-exposure photography has often been used to express something intangible. In the Victorian age, for example, multiple exposures often showed 'ghosts' battling with conjurers. El Lissitzky in the 1920s and Boris Mikhailov in the 1960s–70s both used the technique to express their ideas about Soviet life and politics, with quite different results reflecting their individual perspectives.

Henry Rice's *Mapping* series aims to encapsulate the memory of a place. Several photographs taken on the same day and in the same location are digitally overlaid, with careful consideration given to colour and composition. The result is an image that is a confusion of details; some clear, others indistinct.

Editing software and double-exposure apps make it easy to try out this technique. Make your experiments meaningful by first having a concept in mind that you want to explore.

LEFT:
Beijing from the series
Mapping

Medium as Message

Like many photographic artists working today, Katie BretDay rejects Photoshop manipulation in favour of physical techniques that produce unpredictable results and unique imagery. For this image, BretDay used a combination of acetate, digital printing, cutwork and liquid latex – the latter oozing through the layers, consuming its many figures. The human body is the focus of the series, specifically, the 'materiality of identity and image', so the physical qualities of the piece are integral to it. Here, the latex forms a synthetic skin that leaks, binds and obscures; the choice of this material, in terms of its associations as well as its performance as a medium, represents the themes of sexuality that BretDay explored in this work.

Be experimental in your own approaches to the medium. Consider how you could produce your image, besides printing it onto photographic paper or uploading it to your website or favourite platform. If your photography is about fashion, could the images be turned into a fashion print? If you're exploring an environment, perhaps elements from the world around you could be somehow incorporated. See how far you can make the medium part of your message.

OPPOSITE:
From the series *Lacuna*

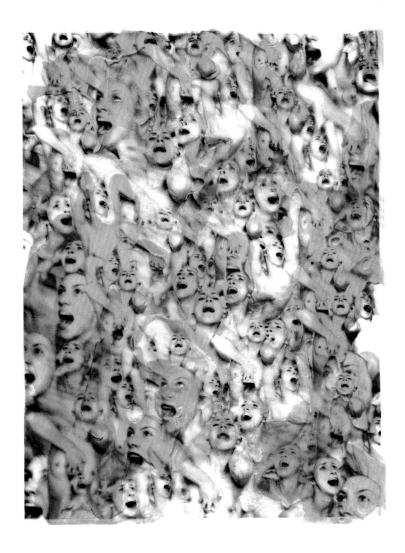

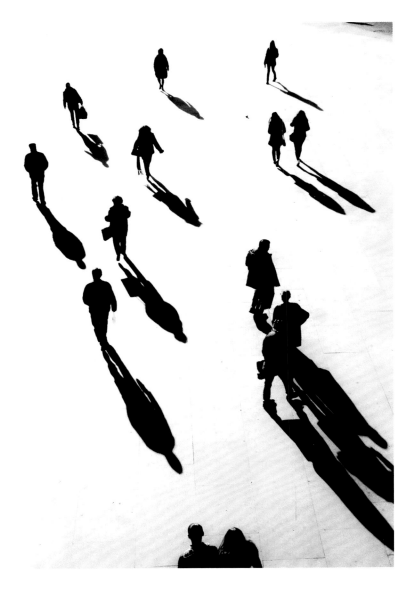

Directional Light

Never let strong directional light pass you by. When the sun is low in the sky, just after sunrise or approaching sunset, there's another dimension to every subject in your frame: their long shadows stretching out away from the sun. The fact that they're all stretching out in the same direction can help bring together disparate elements that would otherwise lack cohesion across the frame.

In this image, Alberto Cabanillas has accented the shadows by converting to a high-contrast black and white. It's a strong, graphic image that would feel empty and weak without the long shadows stretching diagonally across the frame.

OPPOSITE:
People Walking on Street

Thermal Imaging

For her 2016 series *Heat Signature*, Vera Hadzhiyska used thermal imaging to explore human existence. Heat is emitted only by a living body, so Hadzhiyska compares her subjects' individual heat signatures to the unique trace each person makes on the world while they are alive.

Hadzhiyska's project continues a tradition of photography capturing moments not visible to the eye. Typically, this might be a split-second action caught on camera, or a narrow-aperture shot in which the depth of field stretches far beyond the range of the human eye; in thermal imaging, it is infrared radiation, represented through a spectrum of white at the hottest end of the scale, through yellow, orange, red, purple, green and finally blue at the opposite, coldest end.

RIGHT & OPPOSITE:
From the series
Heat Signature

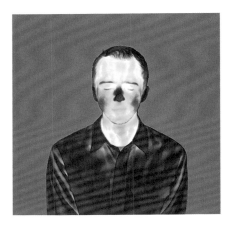

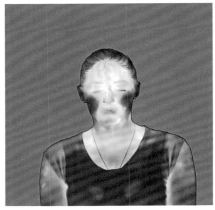

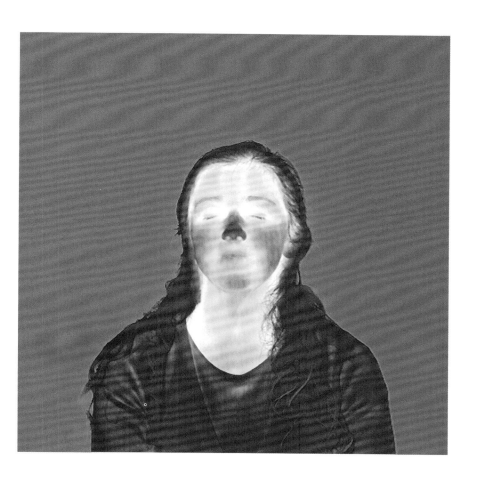

Destroy Your Negatives

Zak Dimitrov's technique was born through his frustration with the tiny imperfections in his images. Dimitrov began deliberately scratching and bleaching his negatives before developing them. The effect lies somewhere between representation and abstraction; parts of the captured images remain tantalizingly visible, but colours, shapes and textures dominate. In this technique, there is a push and pull between chance – with little control over the bleaching process – and intentionality – all those precise scratches. The viewer is encouraged to approach the results like one of Rorschach's ink blots, with their own interpretations and associations.

OPPOSITE:
From the series
Ruptured

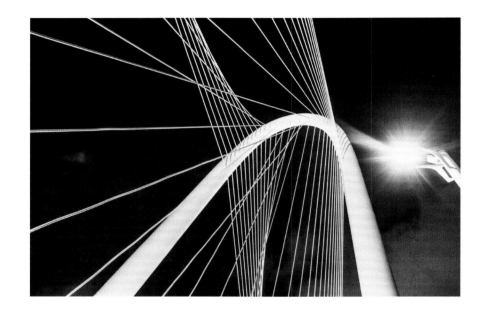

Follow the Lines

The bigger the urban structure, the more potential it has to be captured from an exceptional viewpoint. Massive edifices like this bridge can become abstract from the right angle, particularly when converted to high-contrast black and white, as photographer Timothy Kolczak has done here. The combination of all these lines gives a wobbly sense of depth – the correct perspective slides in and out of view, so the viewer's eyes are led around and around the frame.

The next time you're photographing a building or structure with strong geometric elements, take the time to scout out an unusual perspective that does more than just document its appearance.

OPPOSITE:
*Monochrome Metal
Wire Bridge*

On the Grid

Sometimes foreground elements are just a distraction, but other times they can be used to frame the subject itself – or multiple subjects, in this case. In this image, René Burri created a powerful composition by using the windows to contrast geometrically with the diagonals of the stairway beyond, and also to obscure the figures walking up and down them, leaving only their eerie shadows and the feeling that we're looking in from outside.

Look for grids in the world around you. Modern urban environments are particularly good for this – think of glass office blocks, shopping malls, railings and car windows – and don't limit yourself to a horizontal; by getting up high and looking straight down, you'll find road markings and structural elements provide a grid. Zoom lenses can be useful for abstracting the grid and subjects within from their wider context.

OPPOSITE:
West Germany. West Berlin. 1957. Interbau. International architecture exhibition

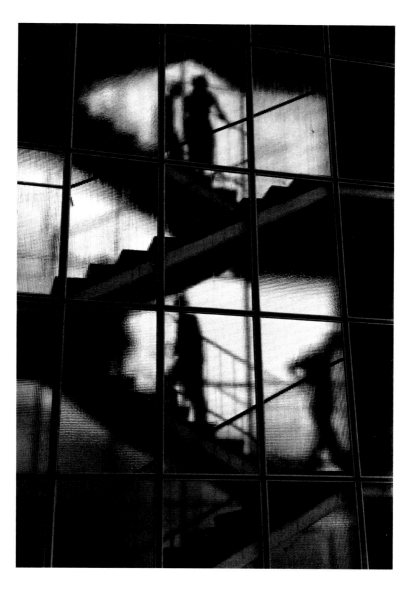

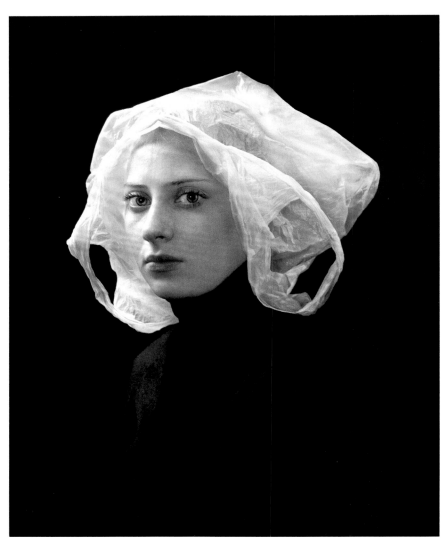

Mimic the Masters

You don't need to reinvent the wheel when planning your next portrait session – there's a rich history of portraiture that embraces a huge variety of styles, many of which translate well to photography. Here, Hendrik Kerstens mimics the Dutch tradition, using chiaroscuro lighting and a classic pose, while firmly situating the portrait in the modern age through the simple use of a plastic bag in place of a bonnet.

This approach works for other subjects besides portraiture: try stealing the composition of a still life arrangement, emulate the impressionists by obsessing over the perfect light for a landscape you want to shoot, or turn your hand to surrealist techniques such as collage. With all of art history there for you to mine, you should never be short of ideas.

OPPOSITE:
Bag

Paint Dipping

Cody Davis had the simple idea of painting this orange to match the blue background, creating a simple, strongly graphic image built around the contrast between the complementary colours. If colour is an object's main feature, this is a great way to draw attention to it. You could apply this technique to portraiture by painting out all but, say, your model's eyes and lips (make sure to use paint appropriate for human skin) and colour matching the background.

What is particularly clever about this image is how the use of colour draws attention to the succulent-looking fruit inside. It looks tantalizing. This technique would work on many things, but the surprising contrast might be strongest when applied to an organic subject.

RIGHT:
Blorange

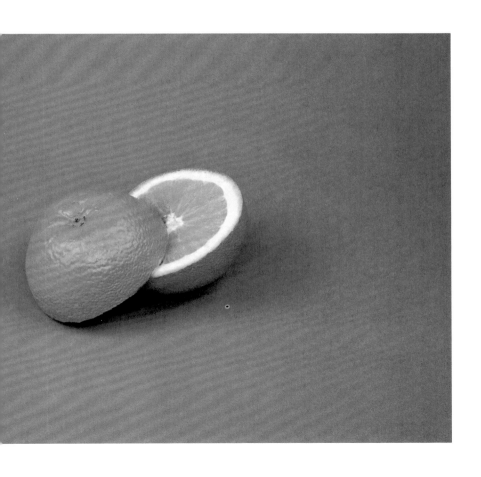

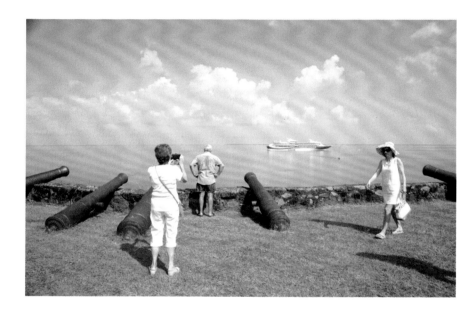

Juxtaposition

In the 1970s, Susan Meiselas documented the Sandinista revolution in Nicaragua, so she is no stranger to conflict in Central America. In 2018 she travelled to Trujillo in Honduras to tell the story of a different conflict – specifically, the pushing out of the local Garifuna people by the burgeoning tourism industry. Meiselas capitalized on the juxtaposition between tourists taking snapshots on a sunny day while a cruise ship loiters in the distance, and the cannons that clearly speak of the country's colonial past suggesting a sense of history repeating itself. Modern forms of invasion and encroachment may be less violent than those of history, but they can be just as devastating.

When you're travelling, do your research to learn about your destination's history, and keep an eye out for where the old mixes with the new, or where visual elements tell conflicting stories. See what kind of narrative you can build by placing them together in a frame.

OPPOSITE:
HONDURAS. Trujillo.
2018. Tourists visit Fort
Santa Barbara

React to Music

Simon Bray investigates our connection to place and the
influence of that on our identity. The images shown here are
of the locations that inspired the seminal 1982 album by Brian
Eno, *Ambient 4: On Land*, and were made using a Pentax ME
Super camera and Ilford P2 Super film – both first created
around the same time the music was.

For this immersive project, first, Bray tracked down the
four locations featured on the album: Lizard Point, Lantern
Marshes, Dunwich Beach and Leeks Hills, in Cornwall and
Suffolk in the UK, and took the strange and ethereal music
as the jumping-off point for his photography. The resulting
images are a personal reaction to the landscape in combination
with the experience of listening to the music, which has a
transformative effect both on what is seen and what imagery
is produced.

OPPOSITE:
From the series
Ambient 4: On Land

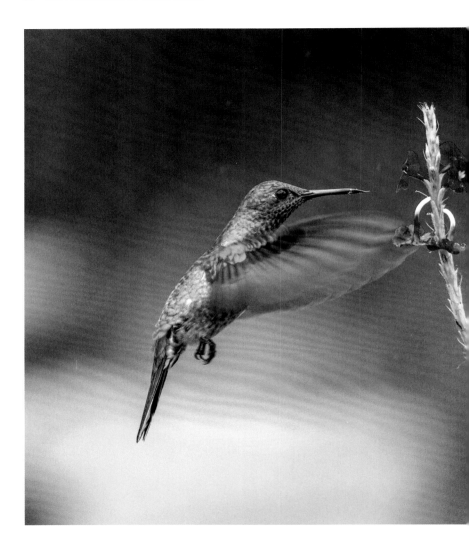

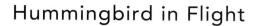

Hummingbird in Flight

Photographing hummingbirds is a rewarding exercise in patience, and much easier than you might expect, particularly with the excellent performances of today's modern sensors. It used to be that capturing such a quick creature (a hummingbird's wings beat roughly 200 times per second) required an elaborate flash setup, but today, if you have a decent DSLR camera, you can make do with simply a telephoto lens and a hidden spot where you can wait for a hummingbird to fly up to a well-positioned flower, as Zdeněk Macháček did to capture this shot. Use aperture priority to keep your aperture as wide open as possible, set a reasonably high ISO, and with good light, you'll likely be able to get a fast enough shutter speed for some crisp shots.

Hummingbirds may be found in some zoos as well as in the wild. If you don't have access to these paragons of speed, you can try practising your high-speed captures on more commonly found subjects, such as birds feeding or a dog shaking itself after a swim.

LEFT:
*Scaly-Breasted
Hummingbird*

Think Big

This image was one of the first Matthew Broadhead shot as part of his project *A Space for Humans: The Moon on Earth*. The project was inspired by trips undertaken in the 1960s by NASA astronauts and personnel from the US Geological Survey to various terrestrial sites deemed environmentally or geologically similar to the Moon in preparation for landing on its surface. In 1965 and 1967, the endeavour took the astronauts and scientists to Iceland, where Broadhead followed in 2016.

In his choice of subject, Broadhead wanted to explore his interest in geology and astronomy, but he also deliberately pursued an ambitious project – one that would take him out of his comfort zone. To do so, the then 22-year-old British photographer got in touch with Örlygur Hnefill Örlygsson, owner of Iceland's Exploration Museum, who offered Broadhead accommodation and access to the museum's collections, which included a permanent exhibition dedicated to the astronauts' training program in Iceland. Broadhead knew what he wanted to do, he was not daunted by the scale of his ambition, and in the end all it took was one phone call to set the project in motion.

..

OPPOSITE:
Seltún Geothermal Area
from the series *A Space*
for Humans: The Moon
on Earth

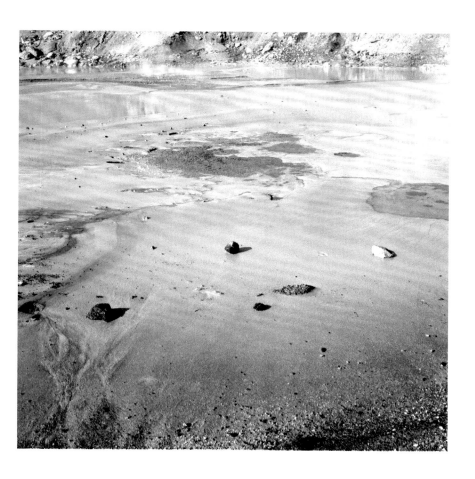

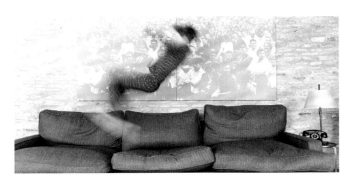

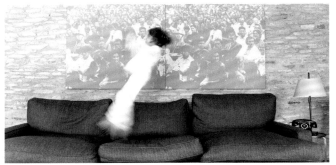

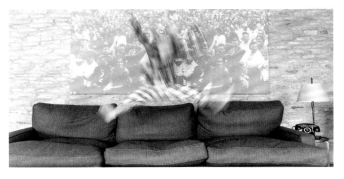

A Different Family Portrait

Kids never want to sit still, right? Fine: capture them as they really are – a blur flying through your field of vision. By deliberately allowing a little (or a lot of) blur from your subject, you can effectively convey movement and energy.

For these images, the camera was set up on a tripod so that the framing was identical from shot to shot. A slow shutter speed (with a narrow aperture) was used while the kids jumped about, resulting in a family portrait that captures the spirit of their youthful exuberance.

OPPOSITE:
Untitled

Connect with Strangers

Crash Taylor is a university lecturer and 'photography addict'. To date, he has captured over 200 portraits for his body of work titled *Strangers of Nottingham*. To make them, Taylor wanders the streets looking for people who intrigue him and who are visually interesting – it could be something about their hair, their face or their individual style. Approaching strangers can be intimidating, but take encouragement from Taylor who says that nine out of ten people agree to have their portrait taken.

Troubled by people's isolating obsession with their phones, Taylor initiated the ongoing project out of a desire to connect more with people. After capturing their portrait, he asks each stranger to make a wish before they part, as a way of rooting the deeper engagement Taylor desires. Indeed, the photographer has made friends both in his city and from around the world through this project, and he says that the 'top three wishes are about peace, health and happiness.'

OPPOSITE:
I wish for a car from
the series *Strangers
of Nottingham*

Kitchen Space

Plamen Yankov's *Planets* is a journey into space – made from the confines of his kitchen. The aim of the project is to explore the banality of everyday life and objects. As the photographer says: 'By exploring the environment around me, I am discovering many everyday things that resemble different planets.' His setup is disarmingly simple, yet highly effective. The 'planets' are created from different fruits and vegetables that have been photographed on a dark background using a bare flash to give hard light from the side.

Combine macro photography with flash to create a moonscape out of salt, or suggest a UFO with the reflection of coloured lights on a spoon. Be inspired by the things in your kitchen, and challenge yourself to transform them into something otherworldly.

RIGHT & OPPOSITE:
From the series *Planets*

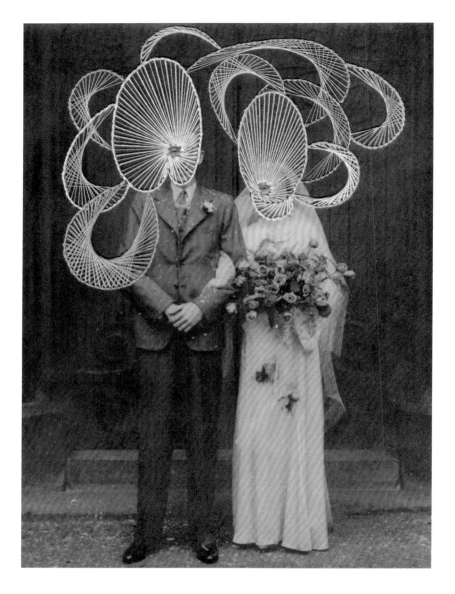

Embroidery

In his mixed-media pieces, artist Maurizio Anzeri embroiders vintage black-and-white prints. Here, lines of white thread radiate from one of each of the subjects' eyes, swirling above them to create an eerie yet captivating image. Anzeri's focus is portraits, his embroidery creating elaborate masks that distort his subjects' features, with results somewhere between the uncanny and the sublime.

This technique works with any number of subjects beside portraiture. The key is to have an idea of what you're creating before you start so that you augment or transform the original photo rather than simply decorate it.

OPPOSITE:
I Will Be With You The Night Of Your Wedding

Play with Reality

Dávid Biró's work examines concepts of reality and knowledge in relation to human perception – in particular, the way we perceive photography in the era of digitally augmented or created imagery. The clever setups in his *Front End* series deliberately invite uncertainty, mimicking the aesthetics of 3D graphics and video games to make the viewer question whether what they are seeing is 'real' (and perhaps, even, what is meant by this term).

Many conceptual photographers turn to everyday objects as an access point for exploring philosophical questions related to the nature of photography. If this is an approach that interests you, the first consideration might be: what aspect of photography most intrigues you? And then, how can you represent that in a composition? Limit yourself to a still life subject and challenge yourself to explore your question through the tools of photography: the setup, the framing, the lighting, post production and so on.

OPPOSITE:
Front End #03 from
the series *Front End*

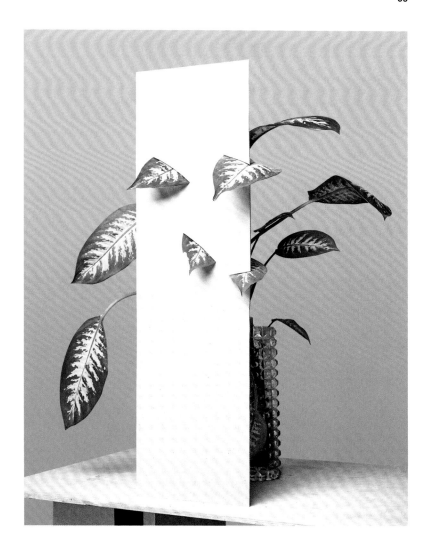

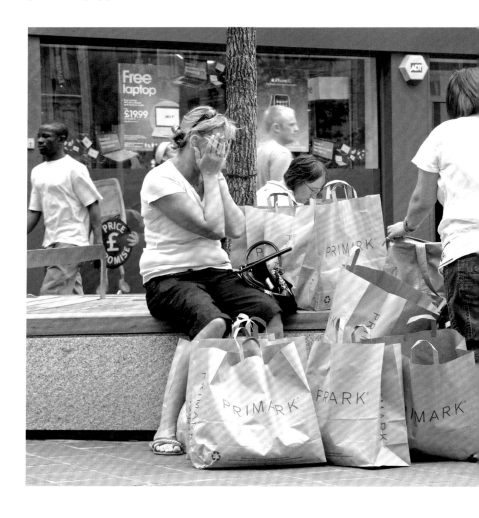

The Everyday Absurd

The Caravan Gallery is a collaboration between photographers Jan Williams and Chris Teasdale who aim to capture 'the reality and surreality of the way we live today'. Their photographs are amusing, ambiguous, ironic or tragicomic; there is an instant reaction to the imagery, but because the scenarios they capture are typically absurd, they are also thought provoking.

In the image shown here, for example, we might wonder whether the woman is covering her face because she is exhausted after excessive retail therapy, or because she is upset that she's forgotten something.

Bizarre moments occur all around us, and once you start noticing them, it's hard to stop. This makes the everyday absurd an excellent focus for a street photography project.

LEFT:
Shopping Fatigue,
Liverpool

Shadow Play

Man Ray was a visual artist best known for his surreal photography. In this iconic image, he has used directional light through a sheer lace curtain to cast shadows onto the model's body, delineating and accentuating her form.

You can achieve this effect by placing your model next to a window, doorway or any strong, bright light source. Try to eliminate all other light sources, and choose a material that allows some light through in patterns, holes or lines – slatted blinds can work well. Suspend this in front of your model and adjust the position of the light or your subject until you're happy with the effect.

By exposing for the strongly lit, lighter skin tones, the unlit area in the background of your composition will be underexposed and dark. You can create an even more powerful contrast when you come to the post-production process.

OPPOSITE:
*Le retour à la raison
(Return to resason), 1923*

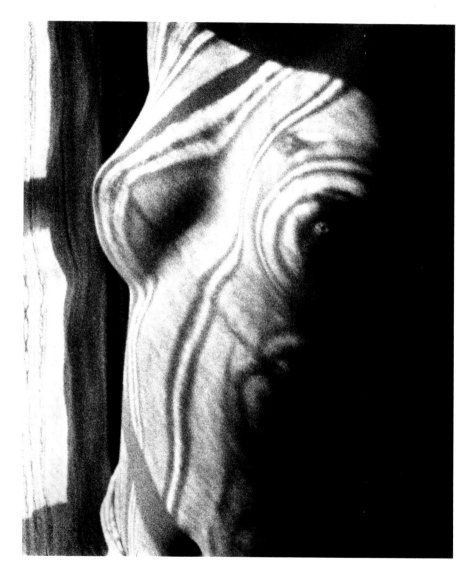

Dream Collages

In his *History of Aviation* series, Kamil Vojnar employs a combination of digital and manual techniques; he creates heavily layered collages comprising many different images from many different sources. Printed on fine art papers and mounted onto canvas or wood, he seals the works with varnish, oils and wax, finishing them with a painterly, distressed surface. The results are dreamlike pieces that are typically both romantic and unsettling. As Vojnar sees it, the challenge in this approach is inventing something new out of existing material. He says: 'In a painting, you can paint anything you want. In the photographic [medium], it must, on some level, exist first.'

LEFT:
Catapult from the series
History of Aviation

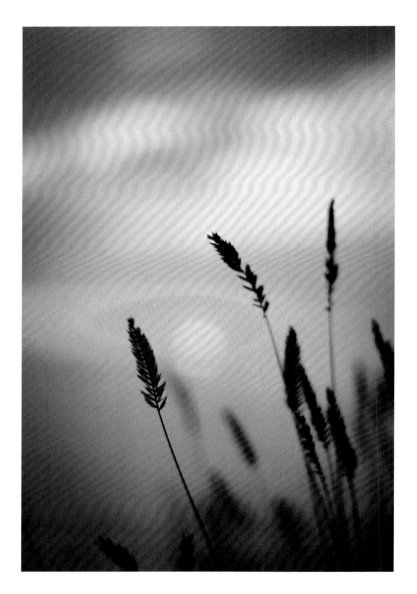

Out-of-Focus Framing

The subject is supposed to be sharp, and the unimportant areas should fall out of focus – right? Not so in this shot by Ann Savchenko, which uses an aperture wide enough to capture a sunset that is blurred but still recognizable. Consider what other subjects might work as just a blurred form – vivid colour helps, as that shines through even when the form is out of focus. Can you give clues or enhance the story by including any in-focus elements in the foreground as Savchenko has done here? You'll be surprised how eager the mind is to make sense of a difficult-to-decipher subject.

OPPOSITE:
Dam of the Kakhovka Reservoir

Blue

Blue is a powerful colour in art. At one time, the blue pigment ultramarine was worth more than gold, and was therefore used only on the most important subjects.

Sarah Le Brocq's *Blue* series is a recent example of how this colour has been adopted as a muse by artists throughout history. In many cultures, blue is associated with spirituality and the divine; in Western cultures it tends also to be linked to ideas of longing and melancholy, as epitomized by Picasso's sombre Blue Period paintings. The associations attached to the colour seem to offer endless inspiration for artists to interpret. Blue also has particular relevance to photography: the blue cyanotype was one of the earliest forms of photography, and Le Brocq has in fact used this process here.

Blue may be the most fêted example of a colour inspiring art, but it is by no means the only option. Each colour has its own symbolism, personal as well as cultural, so you needn't limit yourself to blue.

OPPOSITE:
Untitled #7 from the
series *Blue*

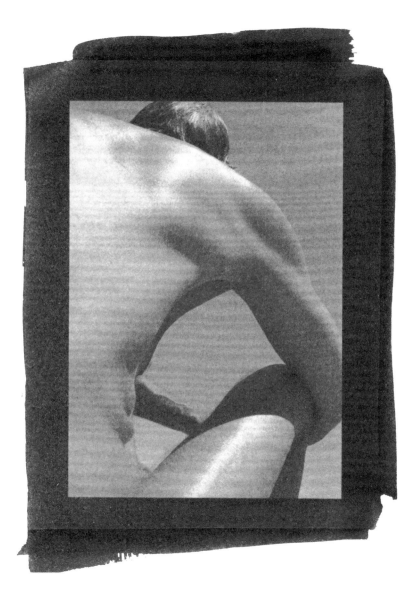

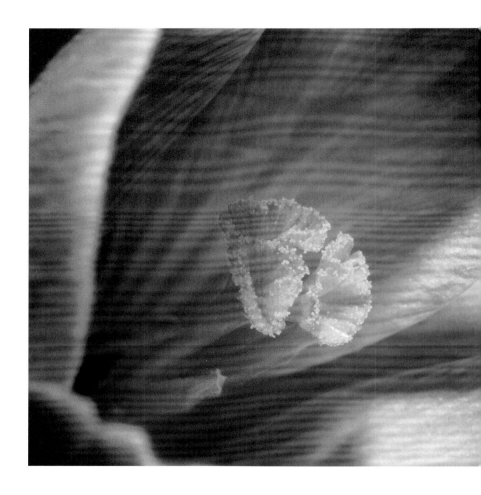

Reversed-Lens Macro

Dedicated macro lenses can be pricey specialist equipment, but a reversing ring is cheap and can give almost any lens macro capabilities. As the name implies, a reversing ring connects the filter thread of your lens to the lens mount, so the lens is attached backwards, or 'reversed'. This increases the maximum reproduction ratio (how large a subject is rendered on a film or sensor, compared to real life), allowing you to get extremely close-up shots of tiny subjects, such as the fine pollen grains of this flower.

OPPOSITE:
Macro Experiments

Cut & Paste

Nick Dolding's *Cut Up* series is an exercise in photographic collage. The technique involves photographing two or more sitters in the same pose and lighting; shooting from the same angle and perspective will also help you bring together the two (or more) separate images. Dolding makes a feature of the joins; by printing onto good-quality, thick, fibre-based paper, he was able to achieve substantial torn edges. Directional light from the right-hand side of the frame produces a dark shadow in the other direction.

This is an arresting image because of its technical precision, but photographic collage can be a much more playful affair, if you want it to be. Take inspiration from the dada and surrealist roots of photomontage and look to artists Hannah Höch and Dora Maar to see how inventive the form can be.

OPPOSITE:
Cut Up 33 from the
series *Cut Up*

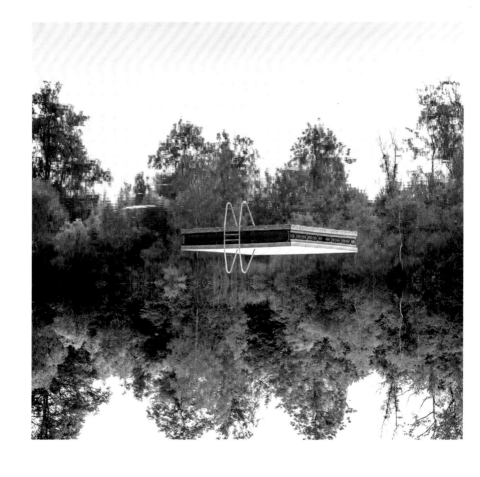

Impossible Reflections

If you keep an eye out for them, there are plenty of scenes that, once framed and captured as a standalone image, appear to defy the laws of physics. Reflections can be really fun to play with in this way, and, as long as you get a decent amount of rainfall in your location, they're not hard to come by. Look out for puddles and still ponds and lakes, as well as reflections in glass buildings, sunglasses or artfully positioned mirrors.

In Mattias Husser's shot here, all it took to make this diving platform appear to be floating in mid-air was turning the image upside down.

OPPOSITE:

Upside Down Image of Diving Platform and Trees Reflecting in Lake

Appropriation

Appropriation of other people's work has a history in art that stretches back over a century, but it realized its most pointed form in the 1980s, when artists such as Sherrie Levine and Barbara Kruger used it as a device to make statements or raise questions about ownership and originality, or to riff on the transformative nature of art.

In this work, Gabriella Blenkinsop creates visualizations of how online data can be taken, manipulated and used in a context it was never intended for. Appropriating images

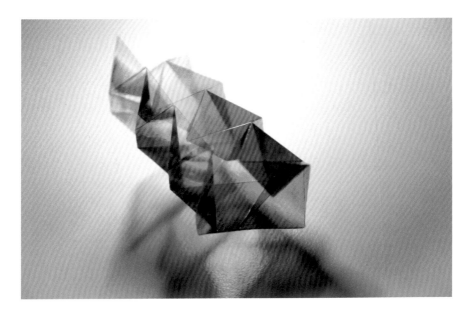

(visual data) from Instagram, she prints the digital images onto acetate and creates sculptures that reference the structural mapping of algorithms. The images are then suspended and lit obliquely to create shifting and opaque shadows.

Appropriation is a valid art form, but it is not uncontentious. If you want to adopt the approach, you should first of all think about whether it is in fact necessary to your goal; and secondly, if you were to profit from the result, have you yourself added enough that you feel this would be legitimate?

OPPOSITE & BELOW:
From the series
#cloud

Neutral Density

A neutral-density (ND) filter extends your shutter speeds even in bright sunlight, giving you the chance to create motion blur in unusual situations. By utilizing the long shutter speed afforded by an ND filter, here, Damon Lam contrasts the craggy, solid texture of the rocks on the left with waves made ethereal by motion blur. There is enough detail left in the waves to give a sense of the violence of the tumult, and the effect is strengthened by converting the image to high-contrast black and white.

OPPOSITE:
630 Ocean View Blvd,
Pacific Grove, United States

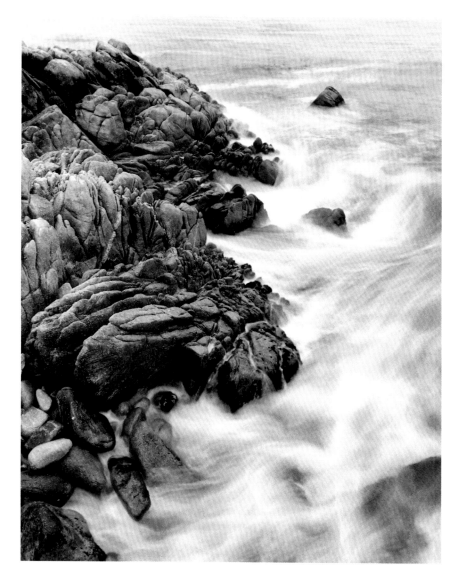

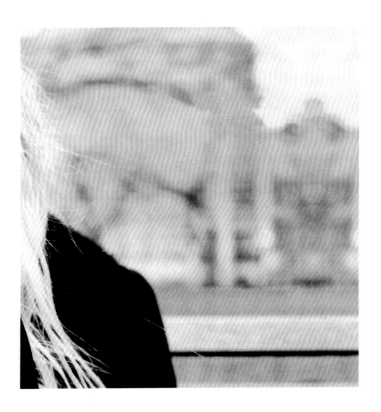

Crop It Out

Photographers usually present their subjects by framing them front and centre, so what happens if you deny the viewer that simple satisfaction? This image is from a series of ten by Uta Barth, each of which teases the viewer with a background that's just clear enough to recognize its form, but blurred enough to remain obscured, and a heavily cropped foreground element. The images are not haphazardly composed – you can see in this example how the framing is squared with the buildings and the horizontal lines at the bottom of the frame – and so the viewer is left to speculate on what may be going on just out of view.

In this series, Barth deliberately disrupts the conventions of photography, forcing the viewer to realize that they are feeling the absence of something they expected from a photographic image – in this case a face, but it could be anything. Defying expectation in this way can surprise and intrigue the viewer, giving your images a different perspective and a distinction.

OPPOSITE:
From the series
…in passing

Whatever's Keeping You Awake

Madison Beach's series of images documents her debilitating insomnia over the course of five nights. Struggling with her Masters degree in photography at the time, by undertaking this project she found a way to use her creative block to her advantage and subsequently found the motivation to start creating again. The setup was simple: the self-portraits were shot with a flash against her bedroom wall, and the resulting images represent her relationship with sleep.

OPPOSITE & BELOW:
From the series
Insomnia

Try making a study of whatever's stopping you from working. Serial procrastinator? Shoot a self-portrait whenever you find yourself fidgeting. Terrible self-critic? Photograph the way you feel about it: if you framed it badly, frame your new photograph even worse; if it's blurry, shoot something entirely out of focus.

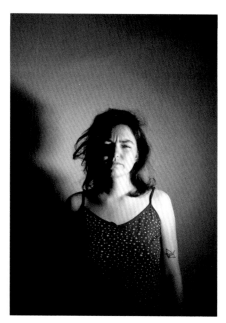
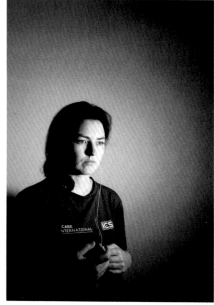

Make a Statement

Two years before Banksy's Sotheby's stunt, Lilly Lulay was already using a shredder to make a point. Lulay's practice is centred around the role photography plays in our everyday lives, in particular, our relationship with our smartphones, the chief medium with which we consume images today.

This piece plays on the format of the Instagram 'Story', as referenced by the elongated print and its stereotypical content. The shredder represents the temporary and meaningless nature of social media. In the Story format, images appear only for seconds before they are replaced by another. The first part of the title – *Sundowner@the Beach* – could be the hashtag; the second part – *recurring cycles* – refers to the rhythm of life, the daily sunrise and sunset and the constant stream of information we are confronted with through our smartphone screens.

To make a statement, you need to consider a number of things: How can you use the medium, the content, the title and the method of presentation to add to your point? Who do you want to reach? Will it be a public installation? If not, where will it be displayed? What feelings do you want to evoke? Will your piece be confrontational, comforting, confusing? The answers you come up with to all of these questions will interact with and influence one another. This could become your life's work if you find enough purpose in it.

OPPOSITE:
Sundowner@the Beach:
recurring cycles

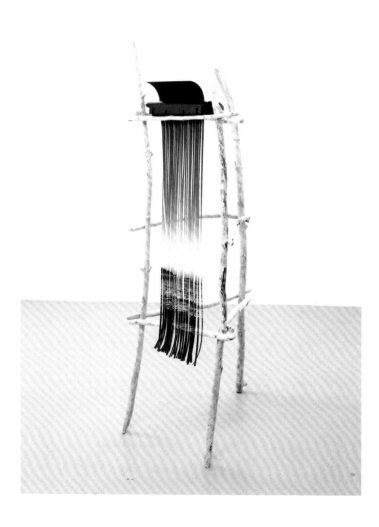

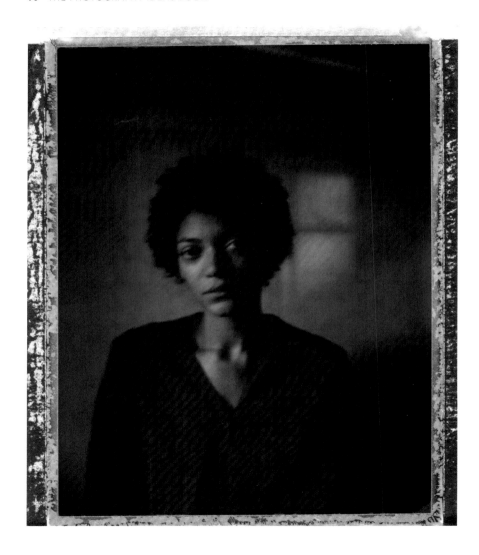

Self-Imposed Limits

Photographer Ed Phillips keeps a written and visual diary documenting his life in London and his relationship with his girlfriend Donnika. Each photograph is taken on peel-apart instant Polaroid film; now discontinued and increasingly hard to find, he relies on a small stock he has saved. When he finally runs out, this project and form of documenting his life will come to an end.

Limitations, as is hinted elsewhere in this book, can in fact turn creativity inside out, opening up worlds yet unexplored. Any parameters placed on a project seem to refine and illuminate the space between them in unexpected ways. Time or another resource being limited can create a sense of urgency; you won't want to waste a moment or a frame on a bad shot. Choosing something rare for your subject matter will sharpen your photographic eye and alertness – and you'll never forget to bring your camera out with you. Choosing an exceedingly simple subject, on the other hand, will teach you to find new ways of looking at quotidian things. And technical restraints will challenge you to find creative solutions to achieving the shots you desire. So why not go and see if limits can set your photography free.

OPPOSITE:
The Blue Hour
(Donnika,
London 2019)

Blurred Nude

Kamil Śleszyński is a former postman, forklift operator and self-taught photographer from Bulgaria, who lives and works in Poland. He defines his focus as broadly documentary, but after his wife became pregnant, his perception of the world shifted, and he was moved to explore a more personal subject.

Prolog, the series from which this image is taken, explores the hopes and fears wrapped up in becoming a parent. This blurred nude conveys the beauty and fragility of this state as well as the delicate relationship between pregnant wife and expectant father.

Long-shutter-speed techniques like the one used here, where the camera was shifted horizontally during the exposure, usually require some trial and error before you achieve the desired effect. But, unpredictable as they are, the results are invariably unique.

RIGHT:
Wife from the series
Prolog

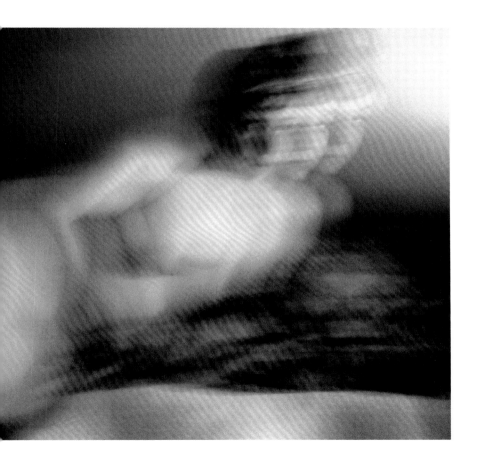

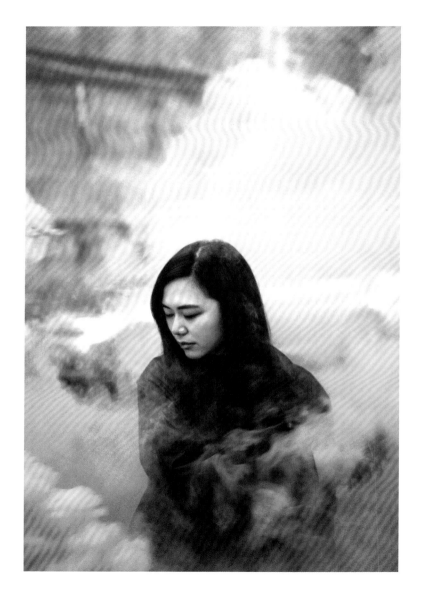

Where There's Smoke...

Chang Liu has a sharp eye for intimate portraits against busy and vibrant backgrounds. For this shot, he brought his own colour and sense of chaos to the scene in the form of a smoke bomb. The model's eyes are closed because the smoke was irritating, but her apparent serenity lends the contrast that is a recurring theme in Liu's work. The contrast between the cool background and warm-coloured smoke makes it that much more poignant.

Shooting out in public, as this photographer does, is so much about the art of seeing, seizing opportunities and grabbing moments; but we can often make our own moments. A smoke bomb is a tiny item you can tuck in your pocket which makes for a big, striking prop once lit. It may cause a scene, draw onlookers or even get you asked to leave – as it did for Liu and his model in this instance – but these elements could create just the excitement your shoot was missing!

OPPOSITE:
Shrouded.003

Theatrical Lighting

During the Second World War, the British Air Ministry commissioned film technicians to create fake cities, airfields, docks and oil refineries, mainly using just fires and electric lights. The objective of this secret simulation was to divert enemy bombs away from the real targets. In 2016, Peter Spurgeon documented what remained of these decoy targets, deliberately combining a dark scene with dramatic lighting to evoke the tense, eerie atmosphere of war.

Theatrical lighting can animate a scene and evoke emotional responses. Natural light can sometimes work as well as artificial, but it's fun to experiment with artificial light sources to create the strongest effects. Use strong contrasts, spotlight effects and careful positioning of light and shadow with a subject of your choice to produce a sense of drama, ambience or narrative.

RIGHT:
From the series *Decoy*

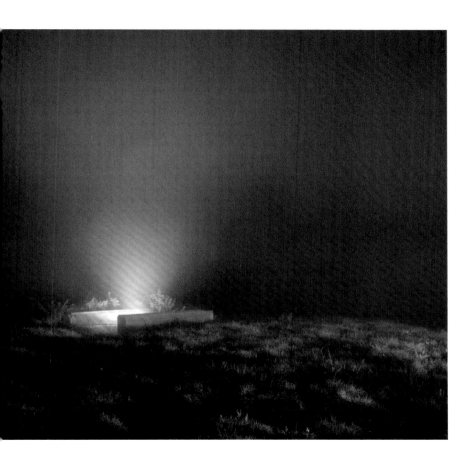

Concentrate on Colour

Adrian Wojtas presents colour as a character in the story each of his images tells. His human subjects are compelling, but often they must share the stage with dramatic hues, even occasionally playing second fiddle. Placing colour front and centre in this way is a hallmark of Wojtas's style and no doubt a symptom of his abstract-formalism leanings.

A scene with contrasting colours and strong graphic elements makes for an image that can withstand high saturation. You can play around with this when shooting and in post-production. See how punchy you can go with your colours while maintaining artistic and technical quality.

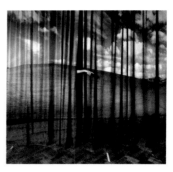

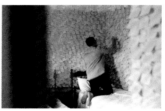

TOP:
< ignorance is >
ABOVE:
Untitled
OPPOSITE:
Artwork for the single 'Full Recovery' by Curtis Walsh

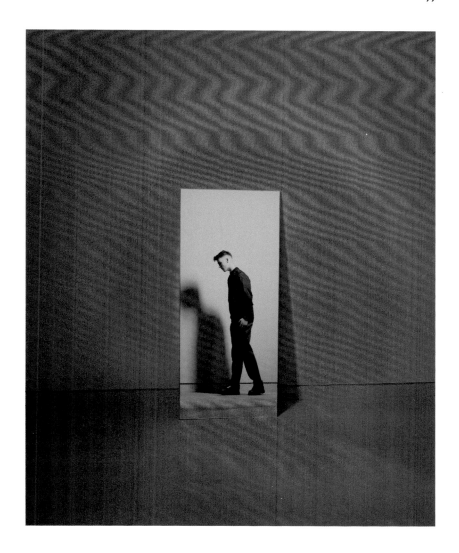

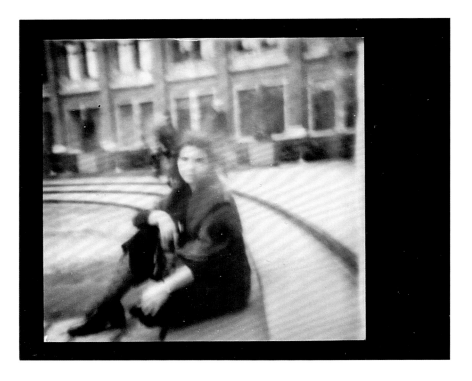

Photo Project

Andreea Andrei began her *Instant People/Polaroid Portraits* project simply out of a desire to shoot portraits of people. Beyond that, she wanted to photograph people as they desired to be seen, as an act of rebellion, an assertion of their individuality, an affirmation that you can be just what you want. She made 26 portraits in total – 26 being her age at the time she completed the project – of people from different types of social and cultural backgrounds. The choice of black-and-white Polaroid film reflects her preference of style, representing the presence of the photographer in the portraits.

You can make a project out of any area of photography that interests you but, as in Andrei's project, it is best to have some limiting conditions that connect the individual images as a coherent body of work. Again, these conditions could be anything: the equipment you use, the timeframe, the use of colour, the use of compositional devices... Choose limitations that will challenge you and keep you interested, or that are relevant in some way to your project.

OPPOSITE:
Carmen Casiuc at the V&A Museum from the series *Instant People/ Polaroid Portraits*

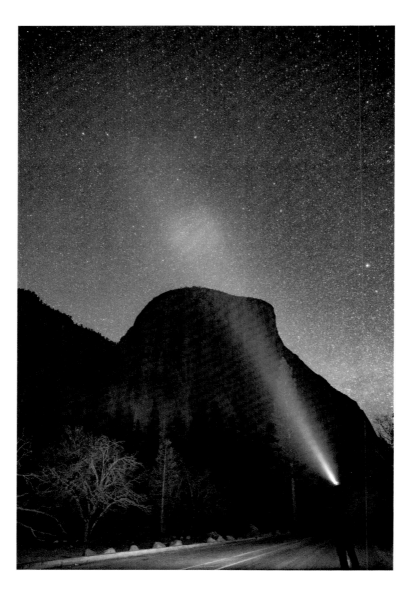

The Night Sky

A long exposure of a bountiful night sky like this one can be enough to make a striking image, particularly with the impossibly dramatic foreground of the American West. Casey Horner enriches this image with a subtle silhouette and a touch of artificial light connecting the immediate foreground to the distant stars.

The night sky offers a wonderful canvas for experimenting with light painting, of which this is a simple but effective example, as well as other long-exposure techniques, such as capturing star trails. Obviously, it works best where there is little light pollution, so it's worth a trip into the wild.

OPPOSITE:
Yosemite Valley,
United States

Get Close

Alix Marie's work explores our relationship to bodies and their representation through processes of objectification, fragmentation, magnification and accumulation. She is interested in addressing gender stereotypes through a visceral, genuine and an often humorous approach. To do this, she gets in close, highlighting details of the human body that might cause discomfort or disgust many.

Photography reproduces reality. While this is not an incontestable fact, it is certainly an aspect of the medium, and one that Marie engages with in an explicit way. Aspects of the body that are normally taboo and traditionally hidden and smoothed away in portraiture are not only displayed front and centre, but augmented and made even more uncomfortable to view by Marie's mixed-media additions. Follow this artist's bold approach by seeking out the elements in your subject – whether it's a model, an outfit, a street scene or a landscape – that don't conform to the airbrushed and artificially created visions of perfection that much contemporary photography favours. Instead of removing these elements, see if you can find a way to celebrate them.

OPPOSITE:
LipWax from the series
Bleu

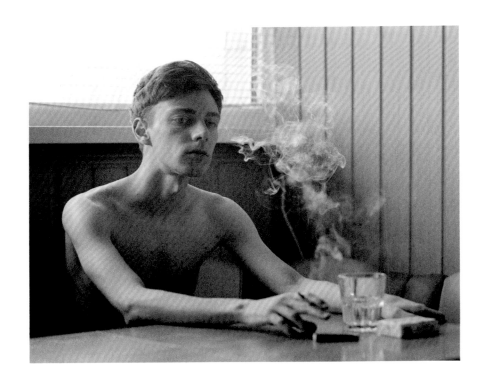

Empathy

Daniel Jack Lyons's portrait photography is largely informed by his experience as a human rights researcher and activist. This work has given him a particular sensitivity towards the subjects he photographs: his approach is 'to focus on individual themselves, rather than their circumstances'. His subjects are often the victims of problems that many turn a blind eye to; for example, the patients of mental health disorders in the Mahotas facility in Mozambique, or the young men and women of Ukraine who have been displaced by political conflicts, documented in his series *Displaced Youth*, an example of which is shown here.

An important part of Lyons's process, one which all photographers should learn from and remember when working with vulnerable people, is respect for his subjects' agency. Rather than imposing his vision upon them, he gives them a say in how they are depicted. The empathy in Lyons's work is striking, and the portraits are elevated because of it.

OPPOSITE:
Breakfast with Alexi
from the series
Displaced Youth

Scan It

Georgina Campbell is a photographic artist with an experimental approach to the medium. One project saw her utilizing the webcams dotted around St Petersburg; the images shown here were made with mechanically altered flatbed scanners. Adapted with timber, cardboard and vintage camera parts, Campbell turned the scanners into portable cameras. The image is captured in a sequence of lines as the scanner slowly makes its way across the image plane; anything that moves within her frame during the exposure morphs and bends creating sculptural forms. Perhaps not everyone possesses the technical skills to turn a scanner into a camera, but Campbell's work demonstrates that there are image-capturing devices beyond the camera.

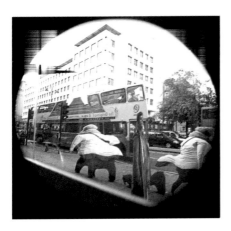

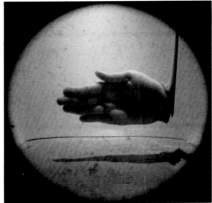

OPPOSITE, LEFT:
Charing Cross, 2010
OPPOSITE, RIGHT:
Hand, 2009
BELOW:
Emmi as a spider, 2013

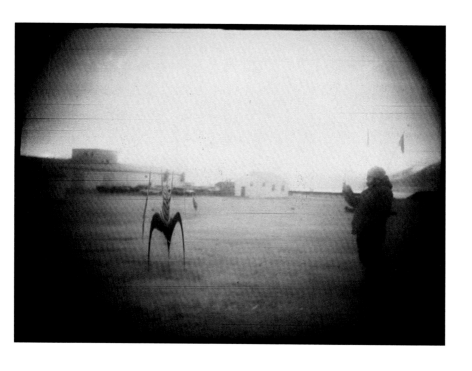

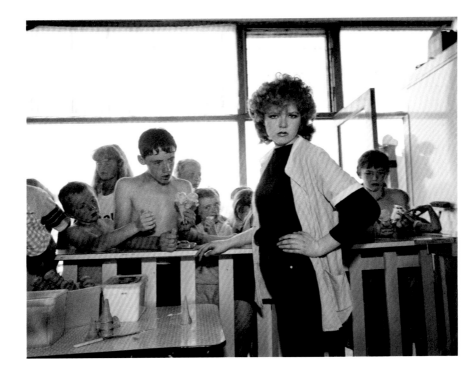

Social Commentary

Martin Parr is a renowned British documentary photographer. This image is from his *Last Resort* series, for which he photographed working-class people at the British seaside over several summers in the early 1980s.

The image has so much going on in it: the girl staring directly at the camera looks fed up, the boy holding three cones is eyeing her up, while the younger boy beside him reaches for one of them. You can feel the heat and smell the cheap ice cream; it's a typical British seaside scene, through and through.

Although Parr has been criticized for his scrutiny of the British working classes, his honest images document a moment in time with both satire and loving attention. It's easy to overlook insidious social changes in our daily lives, but by concentrating on one small section of society in a single location, Parr built an important body of social-commentary work.

Photography doesn't have to be beautiful to be relevant. Find the extraordinary in the mundane, and build a contextual framework into your work by focusing on a theme, whether it is corner shops, sports clubs or your local cafés.

OPPOSITE:
The Last Resort 23 from
the series *Last Resort*

Exploring Environments

In the images for his *Homo (Sovieticus)* series, Lithuanian photographer Vytaute Trijonyte explored how landscape relates to social and political history, as well as the relationship between a person and a place. Working collaboratively with his father in this series of documented performances, the imagery seeks to show the exchanges between landscape, historical context and identity. The interaction between Trijonyte's father and his surroundings is harmonious but uncanny; the poses he adopts are simple but unnatural enough to be jarring, giving a dynamic to the landscape that is rooted neither in reality nor the imaginary, but a careful interplay.

Consider what contextual portraits you might be able to capture of the people in your life: a grandparent who has lived on the same farm since birth, an artist friend in their unkempt studio space, your child amid the mess of a day's playing, and so on. The environment becomes part of the story and tells viewers something about the human subject.

OPPOSITE:
From the series
Homo (Sovieticus)

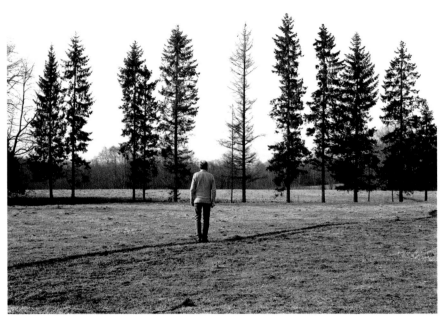

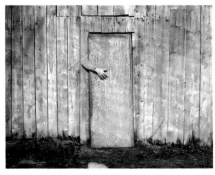

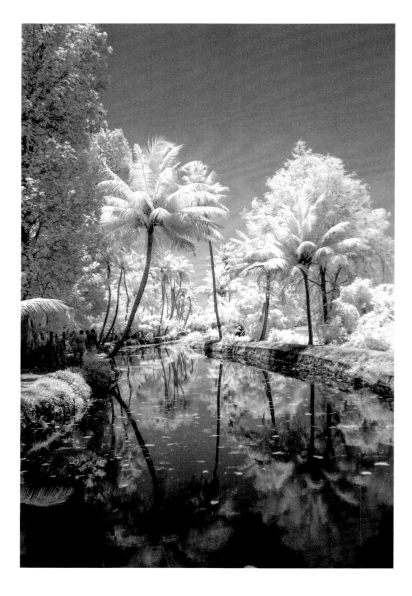

Infrared

The surreal beauty of Adarsh V. Srinivasan's infrared photography shows a quiet, whitewashed perspective of the streets of southern India. Many of Srinivasan's street scenes are chaotic – people, plants, animals, foods and colours abound. The addition of a simple filter to change the type of light captured in photographs shifts the mood remarkably. Skin tones take on a powdery blue cast; scruffy palm trees appear coated in ice and silky-fine snow; everyday activities are transformed, as if taken out of time, and imbued with a dreamlike character.

Infrared photography can be accomplished with a film camera and special film, but many digital cameras are also infrared-capable with the addition of a filter. Film and digital produce different qualities: infrared film photographs feature a halo effect, with a marked reduction in sharpness and therefore producing a dreamy sort of look, while infrared photos captured with a digital camera, like the one shown here, tend to be crisper.

OPPOSITE:
Kerala, India

Faceless Portraits

Oscar Keys's unique portrait style often features subjects with their faces hidden, challenging the idea of what a portrait is meant to be. To some extent, this is an exercise in subverting photographic expectations, not dissimilar to Uta Barth's cropped-out portraits (see page 84). The faceless portrait is immediately mysterious to us. Keys's approach, however, leaves the rest of the frame to play with.

Without a face to capture our attention, these images rely heavily on context and design elements, while notions of identity take a back seat, or can only be guessed at through the viewer's own associations. The colour-matched ribbon in place of the horizon here literally ties the model into the seascape. Keys cites simplicity as one of the key forces driving his approach, and it certainly works in this image, with the limited colour palette and uncluttered composition. However, your own faceless portraits can be whatever you want. A good starting place is to find different ways of obscuring your subject's face and see what each method suggests in terms of a wider arrangement. Consider colours, props, clothing and overall composition – just as you would for an ordinary portrait.

OPPOSITE:
Untitled

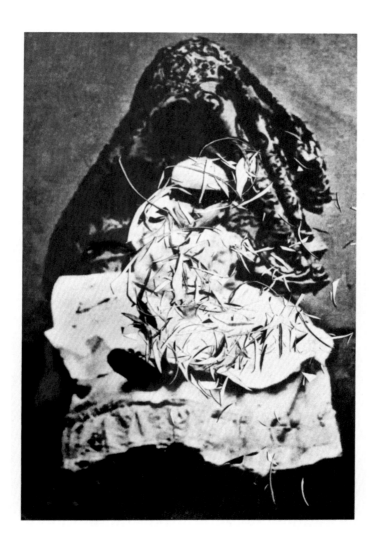

Raid the Past

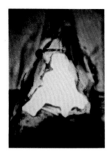

Josie Taylor uses found photographs of babies from the early 1900s to create images that are otherworldly and visually uncomfortable. Early photography relied on a long exposure to obtain an image. To capture an infant child, it had to be held still, often by the mother hidden under a blanket. The original photographs are intriguing and unsettling. Taylor deconstructs and reconstructs photographs by abstracting and layering, sometimes adding paint to the surface of the print, offering the viewer an alternative perspective.

You can often find old prints in vintage shops and junk shops; several museum websites and collections also make high-resolution imagery of out-of-copyright artworks available to download. Search for images with a theme in common. Try collaging them with scissors and glue or digitally, or add other media – or simply use the style, the poses, the colour or other features of the antique imagery as inspiration for your own work.

OPPOSITE:
Masked Baby – Hidden Mother
ABOVE, TOP:
Hidden Mother – Missing Baby 2
ABOVE:
Hidden Mother – Missing Baby 1

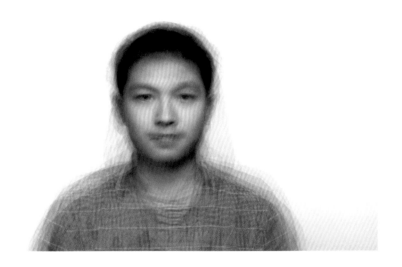

Combined Portraits

Yafei Wang created this composite image of 12 individuals, all fellow students at the University of Brighton in the UK, but who are from different parts of the world. He created an image where no individual is distinctly recognizable. The final image evokes a sense of *déjà vu*, and for the people involved in the project, a sense of familiarity persists.

To create a similar effect requires that the subjects be shot in the same conditions at the same angle. Size can be altered in post-production for a good match, although it will help if you can achieve this in camera by shooting your subjects from the same distance.

OPPOSITE:
Portrait

Form

Bill Brandt is well known for his abstract nudes, unconventional portraits and a documentary series shot in underground air-raid shelters during the London Blitz in the Second World War. His nude portraits featured models' bodies twisted and stacked in strange orientations, often shot close-up, and difficult to discern even as flesh. His shoots often took place on a public beach, where the forms look like driftwood or stone formations against the shingle, or in an empty apartment, where Brandt often utilized unconventional angles to capture deep perspectives and unusual views.

Seeing this model's legs framed just so, in a bizarre position, on the shingle with the sea beyond, makes the human form resemble a sculpture, and we look at it as such, admiring it as something we've not seen this way before. It's this practice of rendering the familiar strange that made Brandt's work so artful and timeless.

OPPOSITE:
Nude, Baie des Anges, France

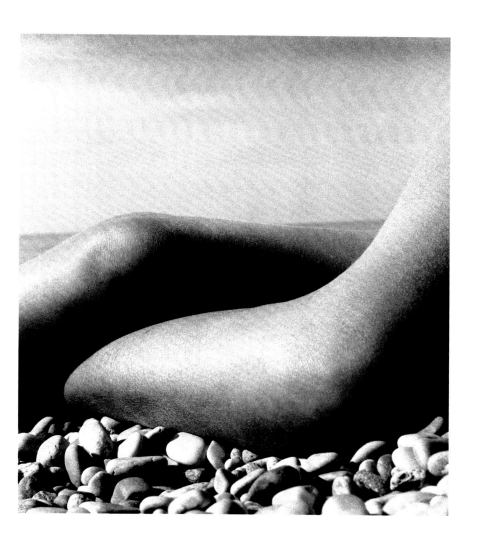

Persona

Blending art with life, Richard Sawdon Smith creates committed personas that become the subjects of his self-portraits. Sawdon Smith describes his practice as 'issues-driven': he has been living with HIV for over 20 years, and his experiences of this disease have been an explicit focus of many of his works.

For *The Anatomical Man* – the alter ego that is the subject of this photograph – he had his back tattooed with the 'autopsy scar' seen here; the front of his body is tattooed with a circulatory system as imaged in a 19th-century book of anatomy. The skull included in this and other images in the series is an even more explicit reference to mortality.

Sawdon Smith offers an important example of the power of persona to highlight social issues and challenge preconceived ideas in the status quo. A persona doesn't need to be as physically extreme as Sawdon Smith's in order to be effective, however; it might be portrayed through costume, makeup, performance or even something as simple as an expression.

OPPOSITE:
Begins from the series
Death of Youth

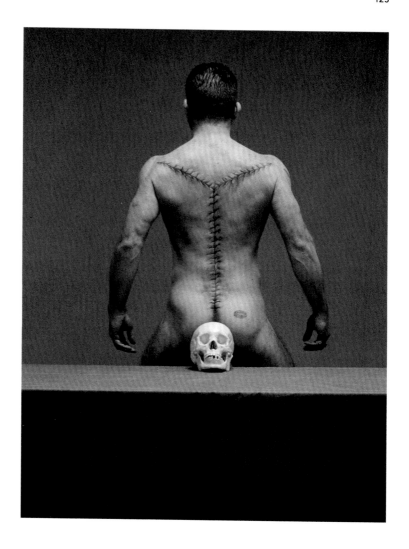

ABOVE:
*Fishing Nets, Lake Biwa,
Japan*

Minimalism

Matt Velarde blurs the lines between abstract and the graphic in his beautiful minimalist landscapes. He travels internationally, searching out clean and uncluttered vistas. His warm-tone monochrome prints and his sensitive use of the neutral-density filter give Velarde his signature style. By using a filter in front of his lens, he cuts down the amount of light reaching the sensor to achieve an extremely long exposure; any movement is blurred, as seen here in the milky smooth surface of the water and sky.

For your own experimentation, consider that something doesn't always need to be happening. A leaf floating on a puddle or a dog lying in the garden, shot with the proper balance, can convey a simple beauty like Velarde has mastered here.

Diptych

Alicja Brodowicz's focus is on subjective documentary and fine-art photography. In *Visual Exercises, A Series of Diptych*s, she pairs close-up and tightly cropped shots of the human body with elements from nature.

Brodowicz's work in these diptychs represents her own philosophy. She states: 'Estrangement from nature has led to the abuse of the environment and the body. Only through a reconnection with nature can we rediscover self-love and make the imperfect body perfect once more.' It is not just that the two pieces are visually similar – the relationship is more complicated than that – it is also about the way the viewer approaches them. For one thing, it reminds us that the body is a part of nature, and when we look at nature, we don't demand perfection from it; its imperfections are perfect.

Diptychs work best where there is analogy or contrast between the constituent two pieces: this creates a dynamic where meaning is enriched. Alternatively, the format can be used to tell a story, in which the two pieces work together to form a narrative whole.

OPPOSITE:
From the series
*Visual Exercises, A
Series of Diptychs*

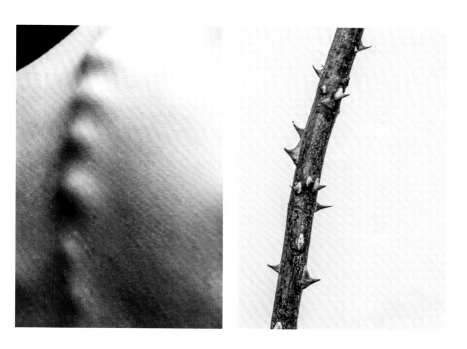

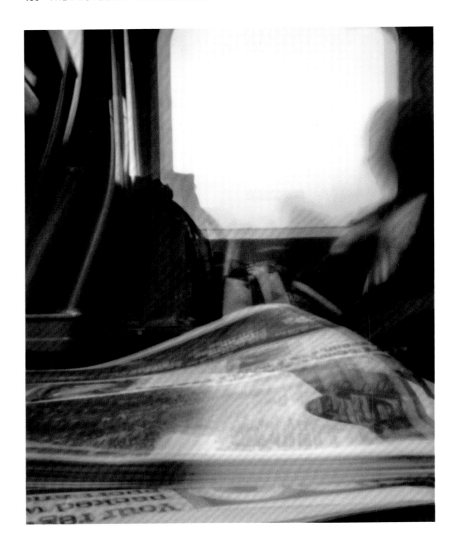

Pinhole Camera

Sam Vale's *Adrift* series aims to capture the particular state of mind that accompanies the experience of travel: the sense of reverie and escape that being between two places can arouse.

Vale wanted to find a way to visualize the temporality of a journey as it was experienced in a sensory way as well as an emotional one. To do this, Vale used a pinhole camera with an incredibly long exposure time, allowing him to record the full duration of the journey from London's St Pancras station to Paris's Gare du Nord. Things that stayed put for most of the journey, such as the passenger opposite and the newspaper on the table, are captured with some solidity, but more fleeting imagery, such as the landscape through the window, either do not register or are blurred beyond recognition.

Pinhole cameras are relatively easy to make and use, but the results can be unpredictable. If you would like to emulate Vale's approach, it would be worth doing a few experiments to assess the optimum exposure time before you commit.

OPPOSITE:
London to Paris from the series *Adrift*

Embrace Imperfection

Thomas Hauser deliberately introduces imperfections to his unusual portraits: his process involves repeatedly photocopying, scanning and printing, cropping and combining them with other, unrelated imagery. For the French photographer, this is about how we engage with memory: we reconstruct and deconstruct events, and they become entangled with a collective memory until a memory perhaps no longer even resembles the original event and is no longer entirely our own.

As photographers, we are usually taught to avoid imperfection: beware of pushing your ISO too high and introducing noise, beware of dust, scratches, light leaks and light flares... Hauser shows that when truly embraced, pushed to the limit – and then some – the sum of all these flaws can result in such unusual and evocative images that you might end up rejecting perfectionism forever.

OPPOSITE:
Hugo (The Wake of the Dust)

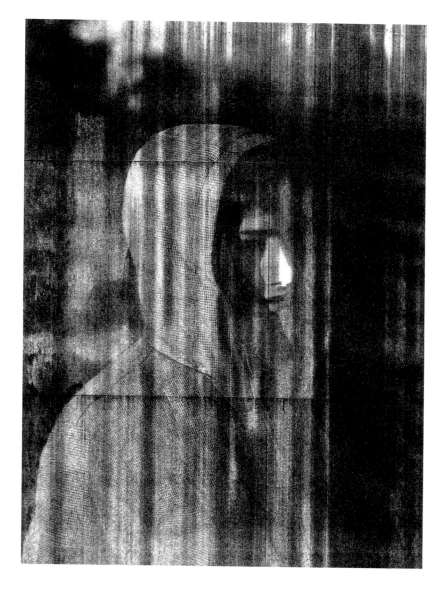

ABOVE:
*100 Planted Saviours of
the Heritage* from the
series *100 Hectares of
Understanding*

Augmented Landscapes

Finnish photographer Jaakko Kahilaniemi's *100 Hectares of Understanding* series documents his relationship with an area of forest he inherited when he was eight. Mixing straight black-and-white landscape shots with simple added graphics, like the lines in the image shown here, the work explores Kahilaniemi's personal feelings about inheriting such a large patch of woodland that he was initially indifferent towards, as well as the relationship between humankind and nature in a more general sense.

Kahilaniemi's approach is reminiscent of the land art movement of the 1960s and '70s, in which artists transformed a natural landscape into art by their physical intervention. Often, this was a temporary and ephemeral change; for example, British artist Richard Long's 1967 *A Line Made by Walking* is a photograph of a path Long had walked into grass.

Consider how you can augment a landscape scene by adding elements, either physically in post-production. Some examples of how you might use this technique include using hand-drawn graphics to convey an atmosphere or emotion connected to the place, or sourcing and compositing historical artefacts into a contemporary scene in order to link the past and the present.

Divide & Lead

Poh Kim Yeoh creates a striking composition through a strict division of space, shape and colour. Inanimate is divided from living, boy from girl, monochrome from vibrant, primaries from pastels, and piles of rocks from one another. The little piles of pebbles, however, provide a connection between all segments of the image, moving the viewer's eye around and around the frame.

This photographer's work is rich with elegant, neat uses of space such as this, but we can all manipulate the concept of division in a way true to our own style. A garden wall cutting diagonally across a busy scene, a model outstretched to separate sand from sea, a road winding off into the horizon – all of these offer types of division you can use to move viewers' eyes into or around your images and keep them engaged.

OPPOSITE
*Children Playing
with Gravel*

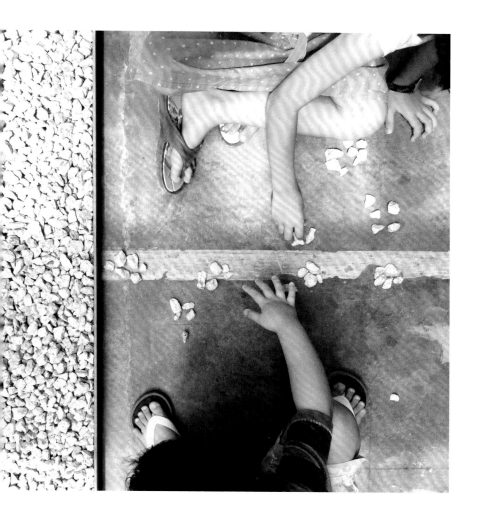

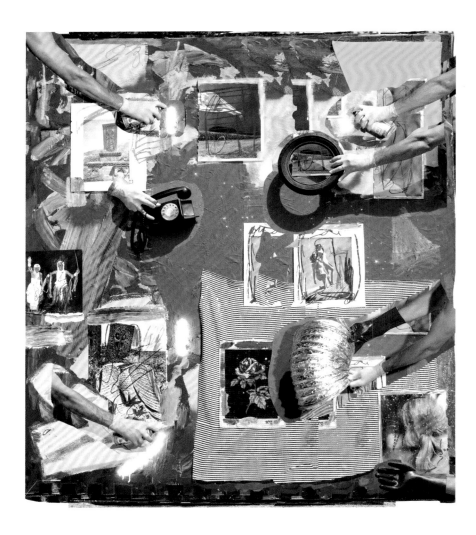

Mixed-Media Performance

Nico Krijno is a contemporary artist who explores photography using sculpture, painting, collage and performance. Working with discarded materials, he interprets and reorganizes them in a non-linear manner, photographing himself working with them and actually creating the piece, pushing the image further with a deliberately heavy hand in post-production, resulting in a flattened, multicolour, layered abstraction which seems to be a chaotic vision of its own creation. This is a playful and intensely creative exploration of what constitutes 'a photograph'. Krijno describes his process as a private physical performance, with the camera being the audience.

If your work is feeling stale, follow Krijno's lead and make creating art a performative photo challenge. Have fun turning your hand to various methods of making art, be sure to photograph every moment of creation, and finish by combining all the resulting works into one final photographic piece.

OPPOSITE
Composition with
Reference Material

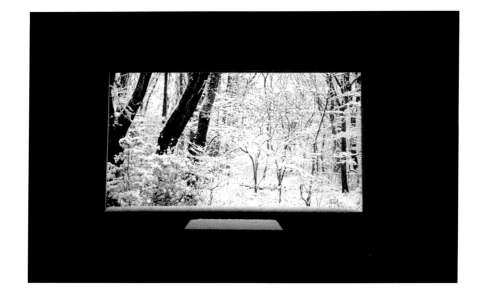

Through the Window

A view shot through the framing device of a window or a doorway can have a completely different impact from the same scene given the whole frame to itself. The frame can suggest distance or separation, or even a sense of the fantastic and unreal. The image shown, from Milo Alexander-Travers's series *Fantasy Point*, is a good example of this.

This image was taken in Nasu, Tochigi, which is situated only 60 miles (100km) from Fukushima Daiichi, Japan. Many were forced to desert here during the 2011 nuclear accident. There is now a real feeling of the absence of families and community, yet the people who remained and the people that have come are slowly building on what's left behind. Through the window, we glimpse a tantalizing scene of Japanese woodland, but it takes up only a tiny part of the frame and is surrounded by darkness.

OPPOSITE:
From the series
Fantasy Point

Glitch

Ernielson Limbo's *Becoming* series is about challenging social constructs, running interference on the notion of binary gender identities in the Western world. To do this, he embeds words spoken by his subjects back into their photograph using digital code, which causes this distortion.

The simplest way to introduce glitches into your digital photo files is to change the extension of the image to a text file extension, such as '.txt'. You will then be able to open the image as a text file (simple text editors work better than more advanced word processors), and see it as lines of code. By introducing new lines and deleting existing code, you can warp your image in all sorts of interesting ways. The results of this method tend to be erratic, but there are dedicated 'glitch' apps available for just this purpose, as well as online tutorials, if you want to bypass the trial and error.

OPPOSITE:
Mia from the series
Becoming

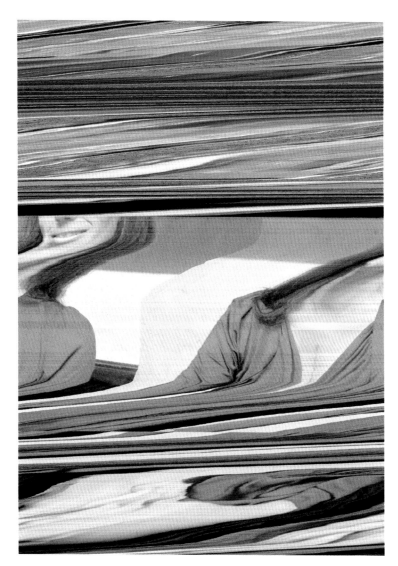

Underwater

Underwater housings for cameras have a certain audience – naturally they're very popular among divers, snorkellers and marine-life enthusiasts – and there is a large degree of novelty in documenting something not typically seen by human eyes. Let us not forget, however, that we can bring more of our world than just the camera into the water and, in doing so, make strikingly artful photographs.

Bulgarian photographer and CGI artist Velizar Ivanov presents a surreal underworld through his water portraits. Making the most of the particular conditions that prevail underwater, his images are spooky, captivating and dreamlike.

Portraits and still lifes are examples of relatively unexplored fields in underwater photography. Because of the buoyant action of water, hair and fabrics tend to waft and billow; meanwhile, suspended in water, your model will be able to position their body in all sorts of ways they wouldn't be able to on dry land. You will see bubbles, colour casts and strange lighting effects – all fun to play with. Also try post-production changes, such as converting to greyscale or monochrome, shifting tones or even creating a composite image.

OPPOSITE:
Flow

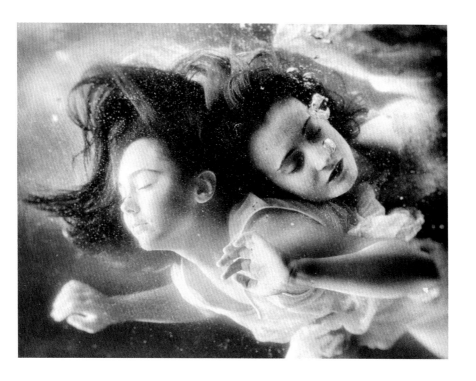

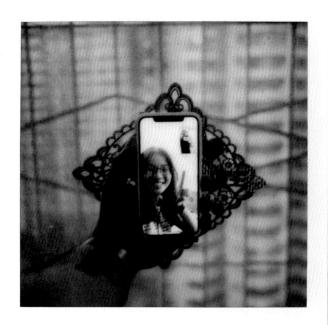

Diary

When photographer Gueorgui Tcherednitchenko spent part of the summer of 2018 in China, his partner stayed behind in London. Unable to be in the same place physically, the couple spent time together on video chat, sharing daily life and the everyday discoveries that travel brings. Tcherednitchenko documented this as a series of video-chat portraits paired with urban details from Hong Kong and China. It ends with a picture of Tcherednitchenko's partner in person at Beijing Capital Airport, upon her arrival from London. Shortly after, he proposed, and they have since married.

A regular photo project with strict parameters is an excellent way of marking a passage of time and documenting change in the manner of a diary. Others have recorded their changing face over a number of years, or simply recorded one photo every day. Tcherednitchenko's project has sharing at its heart, a bit like sending a postcard. The Polaroids that make up the *Long Distance Us* project became a way to reaffirm the couple's connection and make physical mementos of this time spent apart, yet together.

OPPOSITE:
From the series
Long Distance Us

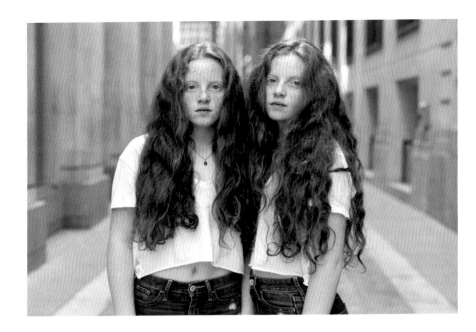

Same Difference

No two subjects are exactly the same, as Peter Zelewski's project
Alike But Not Alike goes to show. The series features portraits of
identical twins of all ages, races and sexes, shot against a neutral
background to counteract any preconceptions the viewer might
have about the subjects' social status or background. What
strikes you first is the similarity between the subjects, but this very
fact, along with the title of the series, invites the viewer to keep
looking until they start to notice the differences between them.

ABOVE:
Emily and Sophie from
the series *Alike But
Not Alike*

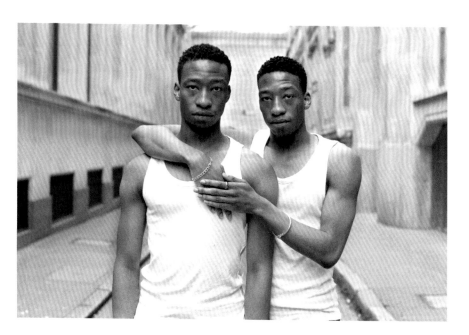

Devontay and Dijon
from the series *Alike
But Not Alike*

When it comes to emphasizing difference, sometimes it helps
to show the same thing. For example, you might make a
statement about personal style by photographing a number
of people wearing the same item of clothing, the look of
which will vary according to their body shape and fashion
sense. It might be a new building development, where all the
houses initially look the same until their owners move in and
gradually fill them with their personalities.

Tiny Planet

Any photo can be made into a tiny planet like this using an expensive fisheye lens or one of a number of more reasonably priced apps available. What makes Martijn Baudoin's shots stand out is his choice of subject. Landscapes and cityscapes generally work best; Baudoin goes one step further by featuring recognizable landmarks. Rome's Colosseum makes this photo eye-catching, and without that familiar element, it might be merely a confusing visual experience.

Baudoin is a well-travelled photographer, and his portfolio features tiny planet shots of famous places around the world. This technique is a fun and fresh take that you can apply to those clichéd tourist shots captured from the same-old overlook or vantage point.

Tiny planet photo apps range widely in price, so read reviews and experiment with a few of them to find one that's easy to use, produces good images and allows you to export at the resolution you need for your purposes.

OPPOSITE:
Palazzo del Colosseo,
Rome, Italy

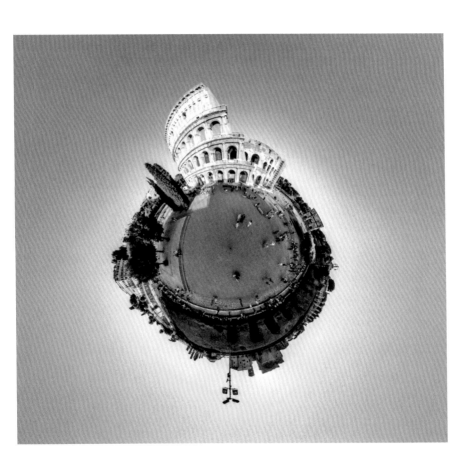

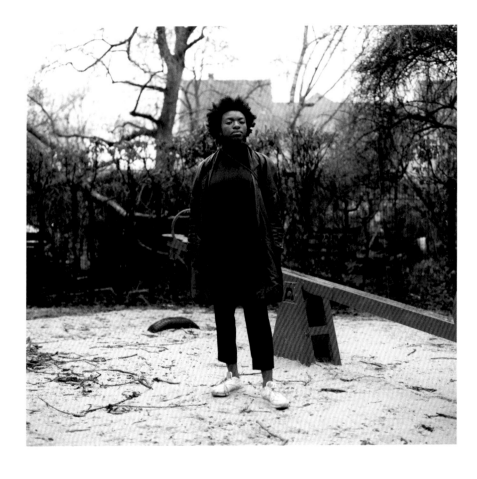

Friends

In some ways, nothing has changed for photographer Finnegan Travers since he was a teenager, when he and his friends would shoot dozens of photographs from their daily life, which they could then look back through. But, he remarks, it gets 'harder to take the ordinary photos that you once did': your style and taste changes; you know more about the art of photography, which can make your practice more rigid and less spontaneous, and your subjects are more self-aware, making it harder for them to act naturally.

Nevertheless, Travers's 'visual diaries' do capture something of that teenage *joie de vivre*. His work focuses on people and the everyday scenes that become the source of private jokes within groups of friends. He is unashamed of the subjectivity of his oeuvre: this is his world we are glimpsing, and if we don't like it, the photographer doesn't much care. But, as is often the case when there is real intimacy and interest between photographer and subject, it works.

OPPOSITE:
Olamiju Fajemisin, Berlin
from the series *Bobby*
Roman: Goodbye Berlin

In Pieces

David Miller's endlessly playful and creative style with posing, props and lighting is matched by his talent for making strange cubist collages from individual photos. His method of capturing a number of Polaroid shots and placing them together to build a distorted image of his model results in compelling and artful final images that are just a little 'off'. The beautiful models appear piled together, as if deconstructed and then sloppily reconstructed.

Photographic collages offer a way to present a different perspective on common subjects and styles, as other works in this book also demonstrate. Landscapes and portraits are obvious subjects for this style, but it could also be an interesting technique for wedding photography, fashion photography, street shots, still lifes and just about any other field of photography.

OPPOSITE:
Annika

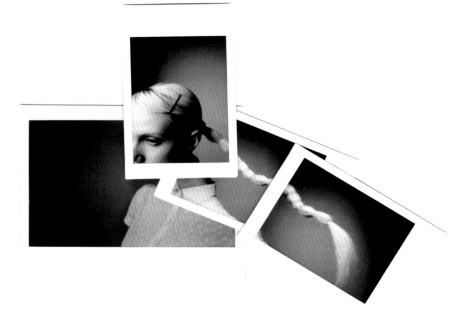

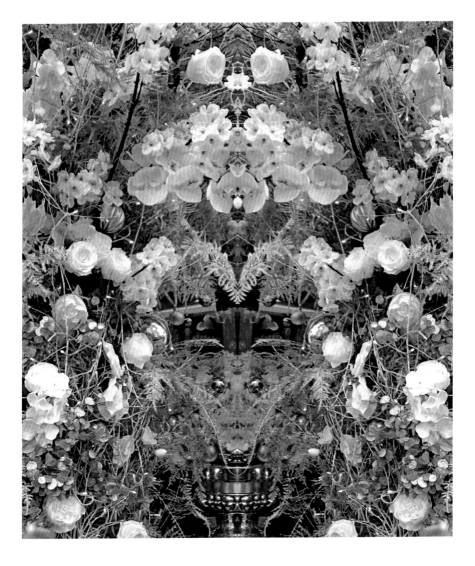

Symmetry

All photographers know that seeking out symmetry is a good compositional trick, but the works in Daniel Teafoe's *Serenity Through Symmetry* project might best be described as 'symmetry on steroids'. His practice is guided by notions of peace, aesthetic harmony and serendipity, and the results are often mandala-like, endlessly satisfying to move the eye around.

It's easy to replicate Teafoe's mirror-and-tile technique using photo-editing software. Simply take a photo, expand the canvas horizontally or vertically, copy and paste the original photo, flip it over so that its edges meet, and keep repeating this process any number of times in any direction you like. You can use just about any photograph for this, although some subjects work better than others. Architectural shots with plenty of lines and geometric shapes to match up are good to work with, as are subjects from nature, such as flowers, that already lend themselves to symmetry.

OPPOSITE:
Holiday Spirit

Indistinct

Muted, pastel colours, low contrast and soft, natural-looking exposures are the hallmarks of Artem Sapegin's style. The Berlin-based photographer never attempts such a wide dynamic range that highlights are blown out or details disappear entirely into the shadows. He does not give in to the urge to tone map or create HDR images, even in high-contrast scenes.

Maintaining beauty and interest in an image with little contrast isn't as simple as Sapegin makes it look. It takes a sharp eye to see a low-contrast scene that will make a great photograph. A dreamy, misty scene like this one is a very good bet, where the indistinct forms of trees are just discernible through the misty sunlight, conjuring a real sense of atmosphere. The approach can also work well for a certain style of portrait of people or animals, close-ups of foliage or flowers, and still lifes.

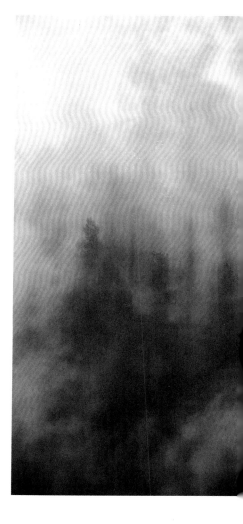

ABOVE:
*Shadows of Spruce Trees
in Heavy Fog*

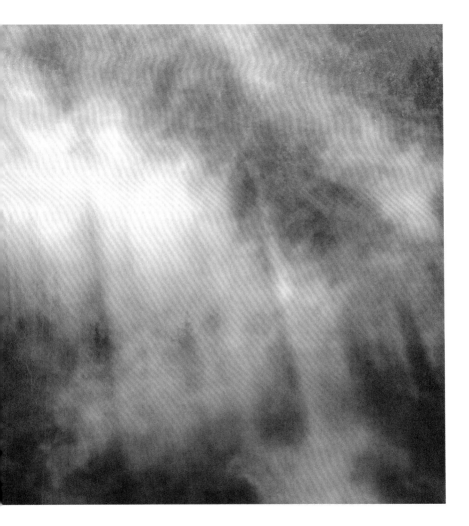

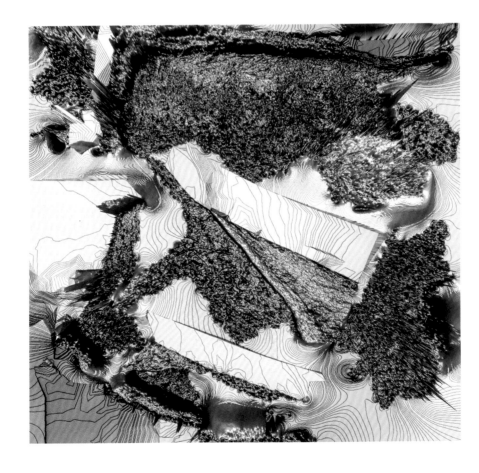

Sensory Responses

In his series *Beyond Words*, visual artist Chris Sykes responds to the power and impact of famous speeches. Sykes takes multiple images of the liquid metal gallium as it reacts with the sound waves of various speeches; the resulting photographs are then processed using high-resolution 3D-modelling software to produce images that condense the whole speech into a single visual landscape.

A complex process indeed – but the idea behind it is essentially: 'How can I portray sound through a visual medium?' The senses of taste, touch and smell are equally applicable to this photographic challenge. A simpler way of portraying sound, for example, might be to photograph the ripples of vibration in a glass of water on top of a speaker. Perhaps you could capture the taste of something by shooting a series of portraits of different people tasting something blindly, then compositing the results into one average response. Alternatively, you might look for things in the world that represent something of the flavour, and present this as a series of images. The creative potential behind this idea is almost limitless.

OPPOSITE:
John F Kennedy: We Choose To Go To The Moon, September 12th, 1962, Rice Football stadium, Houston, Texas from the series *Beyond Words*

Blue Hour

For Cécile Smetana Baudier, this series of fashion portraits for *Vogue Italia* was about capturing the 'blue hour', or twilight. A French-Danish photographer, working primarily in Europe and Africa, Smetana was inspired by a group of Scandinavian artists of the late 19th century known as the Skagen Painters, who travelled to the far north of Denmark just to capture the region's exceptional blue twilight.

The 'golden hour' has long been a photographer's favourite for the beautiful, glowing quality of the light during the period just before sunset or after sunrise. However, it's useful for photographers to be familiar with many different kinds of light. Baudier's photographs prove that the blue hour has the edge over the golden hour for haunting portrait shots; similarly, the harsh light of midday can work a treat for graphic street shots with high contrast and vivid colours. Challenge yourself to shoot at a certain time of day for a period, and you will automatically start pushing your photography in new directions.

ABOVE:
Portrait of Nya Gatbel

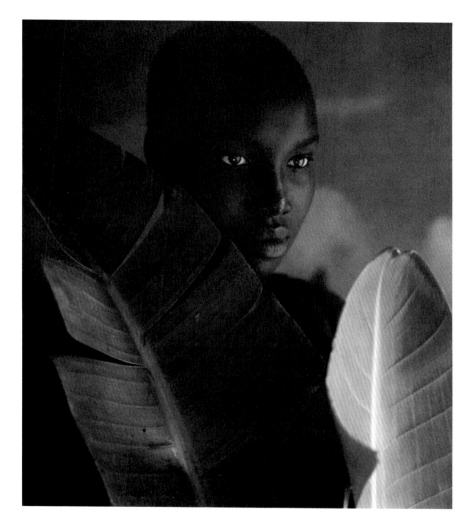

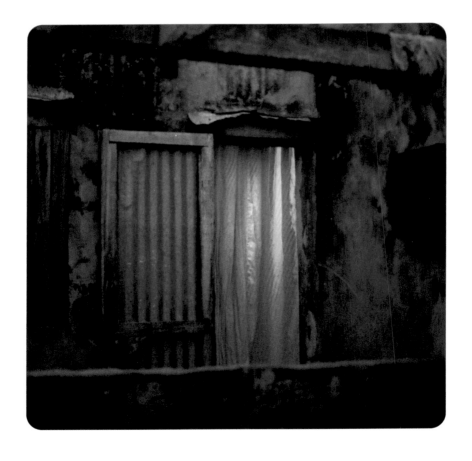

Back to the Basics

In Cristina de Middel's 2012 series *Afronauts*, the Spanish photographer reimagined the efforts of Zambian science teacher Edward Makuka Nkoloso to train the first African astronauts with the aim of beating America and Russia to the Moon. Alongside archive documents and theatrical shots of the 'astronauts' taped into brightly printed 'spacesuits' with fishbowl helmets, there are several shots like this one that feature no people or action, but are just quiet and strange.

Endlessly inventive, de Middel employed a relatively simple concept in this photo: she set the white balance for the coloured light inside, so the twilight outside looks an almost illusory blue-grey. On top of this, the scene has been shot over a wall, in view at the bottom of the frame and out of focus, drawing us to that mysterious doorway. Using these techniques, de Middel inspires curiosity to a point of tension. What is going on inside?

Remember that all the basics of photography that you've learned to get right – focus, white balance, framing, exposure and so on – can be used 'incorrectly' for effect. See what you can achieve just by playing around with the basics.

OPPOSITE:
Lala Kale from the
series *Afronauts*

PRINCE AKACHI
P12–13

MILO ALEXANDER-TRAVERS
P140–141
www.miloalexander-travers.com

ANDREEA ANDREI
P100–101
www.andreeaandrei.com

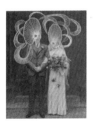

MAURIZIO ANZERI
P60–61

IBRAHIM AZAB
P16–17
www.ibrahimazab.com

UTA BARTH
P84–85
http://utabarth.net

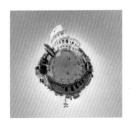

MARTIJN BAUDOIN
P150–151
www.martijnbaudoin.com

MADISON BEACH
P86–87
www.madisonbeach.com

DÁVID BIRÓ
P62–63
www.birodavid.com

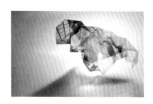

GABRIELLA BLENKINSOP
P80–81
www.gblenkinsopphotography.co.uk

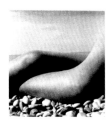

BILL BRANDT
P122–123
www.billbrandt.com

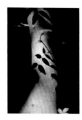

SIMON BRAY
P48–49
www.simonbray.co.uk

KATIE BRETDAY
P30–31
www.katiebretday.com

MATTHEW BROADHEAD
P52–53
www.matthewbroadhead.com

ALICJA BRODOWICZ
P128–129
www.alicjabrodowicz.com

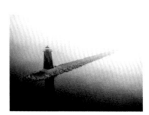

AARON BURDEN
P24–25
http://aaronburden.com

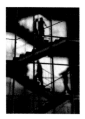

RENÉ BURRI
P40–41

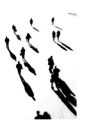

ALBERTO CABANILLAS
P32–33

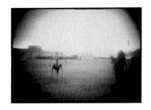

GEORGINA CAMPBELL
P108–109
www.georginacampbell.com.au

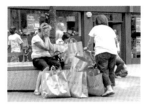

THE CARAVAN GALLERY
P64–65
www.thecaravangallery.photography

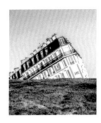

LÉONARD COTTE
P20–21

CAILEAN COULDRIDGE
P22–23
www.caileancouldridge.co.uk

CODY DAVIS
P44–45

CRISTINA DE MIDDEL
P164–165
www.lademiddel.com

ZAK DIMITROV
P36–37
www.zakdimitrov.com

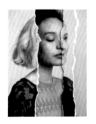

NICK DOLDING
P76–77
https://www.nickdolding.co.uk

MILLIE ELLIOTT
P14–15
www.millieelliott.com

JOEL FULGENCIO
P10–11

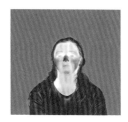

VERA HADZHIYSKA
P34–35
www.verahadzhiyska.com

THOMAS HAUSER
P132–133
www.thomashauser.fr

CASEY HORNER
P102–103

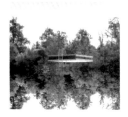

MATTIAS HUSSER
P78–79
https://matthias-hauser.pixels.com

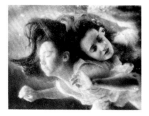

VELIZAR IVANOV
P144–145
https://vlziv.com

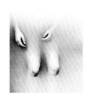

ROSANNA JONES
P8–9
www.rosannajones.co.uk

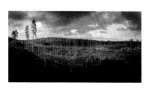

JAAKKO KAHILANIEMI
P134–135
www.jaakkokahilaniemi.com

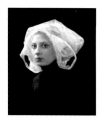

HENDRIK KERSTENS
P42–43
https://hendrikkerstens.com

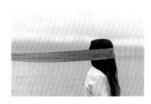

OSCAR KEYS
P116–117
www.oscarkeys.com

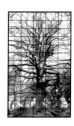

PETE KIRBY
P26–27
www.petekirby.co.uk

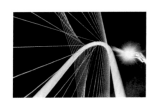

TIMOTHY KOLCZAK
P38–39

NICO KRIJNO
P138–139
https://nicokrijno.com

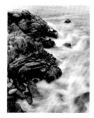

DAMON LAM
P82–83

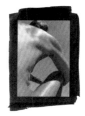

SARAH LE BROCQ
P72–73
www.sarahlebrocq.com

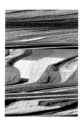

ERNIELSON LIMBO
P142–143
www.ernielsonlimbo.com

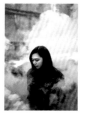

CHANG LIU
P94–95
https://changliu.io/photo

LILLY LULAY
P88–89
http://lillylulay.de

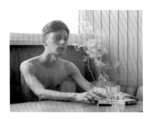

DANIEL JACK LYONS
P106-107
www.danieljacklyons.com

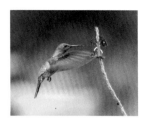

ZDENĚK MACHÁČEK
P50-51
https://zephoto.zenfolio.com

MAN RAY
P66-67
www.manraytrust.com

ALIX MARIE
P104-105
www.alixmarie.com

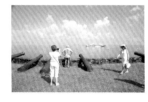

SUSAN MEISELAS
P46-47
www.susanmeiselas.com

DAVID MILLER
P154-155
www.primordialcreative.com

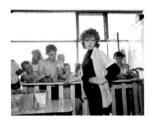

MARTIN PARR
P110-111
www.martinparr.com

FLORIAN PÉRENNÈS
P18-19
https://perennes29.wixsite.com

ED PHILLIPS
P90-91
www.ed-phillips.com

HENRY RICE
P28–29
www.henryrice.co.uk

ARTEM SAPEGIN
P158–159
https://morning.photos

ANN SAVCHENKO
P70–71

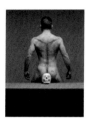

RICHARD SAWDON SMITH
P124–125
http://richardsawdonsmith.com

KAMIL ŚLESZYŃSKI
92–93
www.kamilsleszynski.com

CÉCILE SMETANA BAUDIER
P162–163
www.cecilesmetana.com

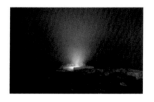

PETER SPURGEON
P96–97
www.peterspurgeon.photo

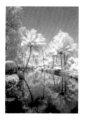

ADARSH V. SRINIVASAN
P114–115

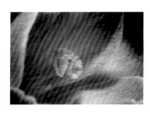

LUCAS STARMAN
P74–75

CHRIS SYKES
P160-161
www.chrissykesphotography.com

CRASH TAYLOR
P56-57
www.strangersofnottingham.com

JOSIE TAYLOR
P118-119

GUEORGUI TCHEREDNITCHENKO
P146-147
www.gueorgui.net

DANIEL TEAFOE
P156-157
https://www.lensculture.com
/daniel-teafoe

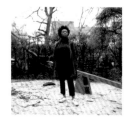

FINNEGAN TRAVERS
P152-153
www.finnegantravers.co.uk

VYTAUTE TRIJONYTE
P112-113
www.vytautephotography.wixsite.com

SAM VALE
P130-131
www.samvale.com

MATT VELARDE
P126-127
www.mattvelardephoto.com

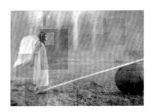

KAMIL VOJNAR
P68–69
www.kamilvojnar.com

YAFEI WANG
P120–121

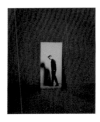

ADRIAN WOJTAS
P98–99
www.adrianwojtas.com

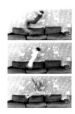

LORNA YABSLEY
P54–55
www.lornayabsley.co.uk

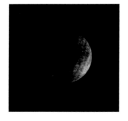

PLAMEN YANKOV
P58–59
www.plamenyankov.jimdo.com

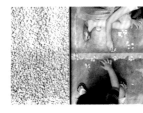

POH KIM YEOH
P136–137

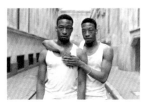

PETER ZELEWSKI
P148–149
www.peterzelewskiphotography.com

PICTURE CREDITS

ACKNOWLEDGEMENTS

With thanks to all the artists for giving
their kind permission to show and
comment on their work.